There are many people and organizations who have helped us during the writing of this book and we would like to take this opportunity to thank them for their support, interest, and assistance. We have particularly appreciated the patience and encouragement from RotoVision, The University of Wolverhampton, our families and friends. A big thank you must also go to all the designers who have so kindly submitted work whether or not it has been included within the following pages.

A ROTOVISION BOOK

PUBLISHED AND DISTRIBUTED BY ROTOVISION SA ROUTE SUISSE 9 CH-1295 MIES SWITZERLAND

ROTOVISION SA SALES & EDITORIAL OFFICE SHERIDAN HOUSE, 114 WESTERN ROAD

HOVE BN3 1DD, UK TEL: +44 (0)1273 72 72 68

FAX: +44 (0)1273 72 72 69 EMAIL: SALES@ROTOVISION.COM WEB: WWW.ROTOVISION.COM

COPYRIGHT © ROTOVISION SA 2007

ALL RIGHTS RESERVED. NO PART OF THIS PUBLICATION MAY BE REPRODUCED, STORED IN A RETRIEVAL SYSTEM, OR TRANSMITTED IN ANY FORM OR BY ANY MEANS, ELECTRONIC, MECHANICAL, PHOTOCOPYING, RECORDING OR OTHERWISE, WITHOUT PERMISSION OF THE COPYINGHT HOLDER.

WHILE EVERY EFFORT HAS BEEN MADE TO CONTACT OWNERS OF COPYRIGHT MATERIAL PRODUCED IN THIS BOOK, WE HAVE NOT ALWAYS BEEN SUCCESSFUL. IN THE EVENT OF A COPYRIGHT QUERY, PLEASE CONTACT THE PUBLISHER.

10987654321

ISBN-13: 978-2-940361-77-9

ISBN-10: 2-940361-77-0

ART DIRECTOR LUKE HERRIOTT DESIGNED BY BRIGHT PINK

PHOTOGRAPHY BY XAVIER YOUNG

REPROGRAPHICS IN SINGAPORE BY PROVISION PTE. LTD.

TEL: +65 6334 7720 FAX: +65 6334 7721

PRINTED IN SINGAPORE BY STAR STANDARD INDUSTRIES (PTE.) LTD

CONTENTS

04/05 INTRODUCTION

06/07 SECTION ONE

16/17 EXO1 EXERCISE ONE <u>CUT-AND-PASTE</u> VISUALIZING

36/37 EXO2 Exercise two Proximity: continuance, and, <u>Similarity</u> 50/51 EXO3 EXERCISE THREE TYPE AND COLOR

64/65 EX04 EXERCISE FOUR SEQUENCING QUANTITIES OF TEXT

82/83 SECTION TWO

98/99 EX05 EXERCISE FIVE CROPPING AND CHANGE OF SCALE **126/127** EXO6 EXERCISE SIX HIERARCHY AND MANIPULATION WITH IMAGERY

150/151 EXERCISE SEVEN DIVERSITY WITHIN LAYOUT USING TEXT AND IMAGE

158 THANKS2

159/160 INDEX

INTRODUCTION

Have you ever been confronted with shelf upon shelf of soap

powders and washing potions and been totally unable to find the one that you want? Every packet, bottle, bag, and box is covered with vivid, colorful graphics vying for your attention and seeking to secure your purchase. This riotous assembly of text, image, and color, with each element appearing to have equal prominence, can be too much to take in at once. When everything is presented in this way, all on one level, whether bright and loud or restrained and quiet, it is difficult to know where to look first, and the design fails to maintain your active interest and concentration.

Over time, most product categories have acquired a distinctive and somewhat synergic appearance, but the soap aisle provides an excellent display of designs that have the same visual emphasis throughout. To create efficient graphic design, individual compositions need to be more sophisticated, to break down information into accessible, appealing levels that engage the audience and ensures its attention and interest. *The Graphic Designer's Guide to Effective Visual Communication: Creating Hierarchies with Type, Image, and Color* looks at the different ways in which designers organize content to reflect varying degrees of importance and relevance, and examines how their results are achieved.

What do we mean when we talk about breaking information down into levels? We mean creating hierarchies by which certain elements are made to appear very evident and others less prominent, with some to be perceived only upon closer examination. This becomes a form of layering information, not physically overlapping elements, although this technique may be used, but a sequencing of different visual ingredients to ensure that the viewer can access each, one by one. Interestingly, it is not necessarily the most important piece of information that is presented in the most distinctive manner, but whatever is considered appropriate as an attention-grabbing device. The concept of the designer building up layers as if forming a "graphic sandwich" can be helpful in appreciating the process of creating hierarchies. Basic, simply expressed information equates to the bread, while punchy, vital, and intriguing content represents the filling. They complement each other and work as a whole to provide variety, interest, and above all, accessibility. A sandwich of all bread or all filling is unlikely to be enjoyable or satisfying; a mix of differing characteristics will encourage the reader to relish and retain the facts presented in any design.

Creating different levels of information is of paramount importance when you want to "drip feed" the viewer easily digestible amounts. In many instances, designs for such things as Web pages, brochures, and posters are charged with communicating a great deal of information. It is not merely to provide visual interest that these hierarchies are created, but also to ensure that the audience is effectively imbibing as much as possible. Image and text are categorized according to a desired order of significance: each category is given individual visual prominence in order to direct the viewer subconsciously from one to the other. To attract attention is the first aim. The order in which levels are viewed could be considered of less significance, so long as one level is sufficiently attention-grabbing to lead the reader to more detail and, ideally, on to subsequent content. There are many and varied methods of drawing attention, from using large type, bright colors, and dramatic imagery, to highlighting more frivolous or obtuse information, or appearing distinctive or unusual. However, regardless of the designer's skilled efforts, there remains the uncontrollable aspect of the viewers' personal perceptions, experiences, and

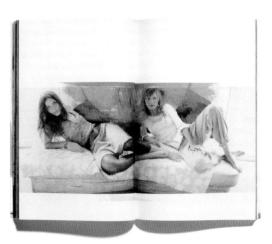

preferences. If their favorite color is pink and they adore dogs, a pink dog, however pale or obscure, can still be the most arresting element within a design!

In some instances, levels of information are not included because their content is essential, but rather to introduce ambient subject matter in order to set the scene or create a mood. This means it is included purely to help construct viewers' dispositions, thereby making them more receptive to the real message of a piece. For example, adding a humorous element not only attracts the reader, but also puts them in a happy frame of mind, leaving them more likely to feel open to the data in the remaining composition. Taking another approach, a subtle persuasion might be included; the luxurious use of space suggests to viewers, on a subconscious level, that the content of a layout is more valuable and desirable.

The Graphic Designer's Guide to Effective Visual Communication showcases and discusses acknowledged and interesting examples of visual hierarchies produced by designers from around the world. Section One concentrates on work that is typographically driven while Section Two focuses on pieces that use imagery to control the sequencing of information. In both sections, practical exercises are included to comment on and highlight certain principles. Good design shows a balance between esthetics and function; creating successful visual hierarchies is an important element in satisfying both.

ELECTRICITY

PUWER

ELECTRICITY

TYPE DRIVEN

Section one examines the fascinating and complex realms of

hierarchies that are typographically expressed. This does not mean that designs do not include imagery, or that images do not play a part in the order in which the content is perceived, simply that the most significant elements are constructed typographically.

Typographic hierarchies are predominantly governed by relationships of texture and tone. Letterforms, words, and lines of type come together to form different tonal values as well as varying characteristics of patterning; depending upon the darkness of tone generated, together with the scale and nature of texture, a viewer is attracted to a greater or lesser degree. Choices of typeface, point size, tint, weight, tracking, line spacing, and general spatial distribution affect the density of the type, and consequently, create differing degrees of light and dark. Similarly, these distinguishing characteristics impact upon the kind of pattern that is made. However, when composing differing varieties of texture and tone, designers should be prepared to make visual judgments. Logically or incrementally based changes can be a good place to start, but will not necessarily result in sufficient, meaningful change or noticeable visual difference.

Position and orientation within a layout have far less significance than density of texture and darkness of tone; key information will still be recognized as having primary importance wherever it is located, providing that it has sufficient intensity. As far as the sequencing of subsequent information is concerned, ever-decreasing tonal values will operate in tandem with Western conventions of reading from left to right and from top to bottom. Designers impose structures and style, but must always recognize the Western viewers' instinctive response to return to the left edge, and to "work their way down" a layout.

It is important to recognize that all typographic tonal and textural qualities are relative, both to each other and to the supplementary text and image on the page. Composition inevitably has a powerful influence; space around type will set it apart and give it more prominence. For example, large, bold, black, sans-serif type is not necessarily more evident or powerful than small, lightweight lettering. If the black type fills an area and bleeds off at the parameters of the page. then the reader is likely to interpret this text as image; position the smaller information in the remaining generous space and the reader's attention will almost certainly be drawn to it. Add the option of reversing type through a black box and the smaller, lighter copy takes on an even greater significance and impact. Imagery, in close association with type, can also make it possible to mute the impact of bold. large, black copy. When letterforms overlap imagery of a similar tone, or intertwine with images, they become less like parts of words, and more significant as shapes within the picture content.

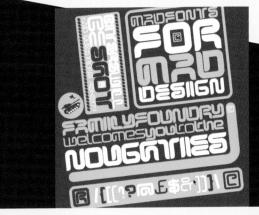

THE BIG HOUSE IS AT THE BOTTOM OF THE HILL

In considering the role of type as a regulator and controller of hierarchies, it is necessary to keep in mind that letterforms make words and words have meanings. Scale, tone, and texture are always going to be relevant, but the actual words that are used also have influence. For example, highly topical subject matter, challenging language, and shocking statements are more likely to attract attention, even when represented with little dynamism. These comments apply to situations such as subheadings and main headings, but also to words and phrases that can jump into the focus of the reader from within paragraphs. Looking at the example shown, it is likely that the meanings of the highlighted words, as well as the emboldening, add to their salience.

Choices of typeface can also influence the ordering of typographic information. For example, certain families are associated with expected contexts and levels of priority. A word generated in bold, sans-serif type, all caps, may well create a strong texture and tone, but it can also have connotations of warning signs, severity, and importance, and therefore manifest more significance within a layout. Conversely, a complex or decorative typeface creating a very similar texture and tone on the page might well attract the reader initially, but because the text is difficult to read, an audience is likely to quickly move on to more accessible words. Some typefaces encompass more subjective interpretations, having personal associations or familiarity, and this too can impact upon progression, whether this be to attract or deter.

The inclusion of color in a layout brings another dimension, another modifier, to the ordering of visual data: luminosity and vibrancy are enticing; softer, paler colors appear to be knocked back; certain colors have connotations that provide meaningful relevance; small amounts of color act as highlighters. However, within the numerous roles that color
 CLIENT
 DESIGN
 TYPOGRAPHY
 ART DIRECTION

 IDENTIKAL
 ADAM AND
 ADAM AND
 ADAM AND

 NICK HAYES
 NICK HAYES
 NICK HAYES

can play in terms of hierarchy, one particular characteristic should not be overlooked, and that is the tonal value. Once again, it is not merely the hue that needs to be selected appropriately, but also the tone. Viewing colored typographic relationships in grayscale gives an excellent indication of prominence and priority. If color lasers function correctly when viewed in grayscale, they will certainly be equally strong in color.

As with all principles of design, those presented here serve merely as general rules and guidelines; there are no definitive dos and don'ts. The following pages in this section include examples and exercises that demonstrate some of the intricacies, fine balances, and anomalies that designers face when creating visual hierarchies.

CLIENT						
LO	RECORDINGS					

DESIGN KJELL EKHORN JON FORSS

TYPOGRAPHY KJELL EKHORN JON FORSS ART DIRECTION KJELL EKHORN JON FORSS

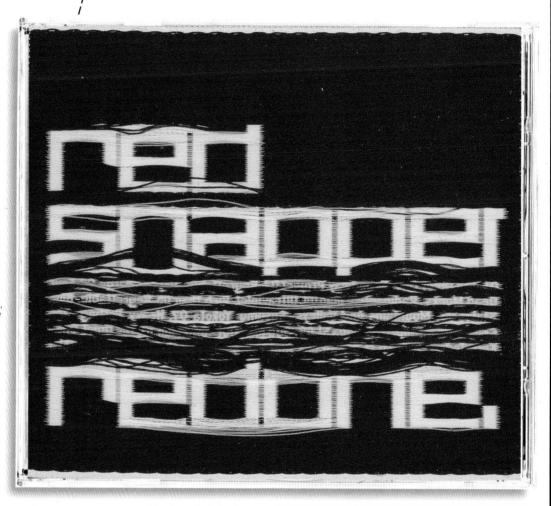

NON-FORMAT RED SNAPPER CD COVER Non-Format's design for this CD cover uses type only, generated in a manner

more usually seen on clothing labels. The reader's attention is instantly drawn to the white letterforms—delicately constructed from hundreds of strands of fine thread—which are intriguing, not only because of the bright colors in the piece, but also because of their scale, contemporary approach, and tactile character. The viewer is given a glimpse of what is conventionally recognized as the reverse of a label.

CLIENT YEAR OF THE ARTIST **DESIGN** DOM RABAN PAT WALKER ART DIRECTION DOM RABAN

Eg.G YEAR OF THE ARTIST BROCHURE This spread from a brochure produced for Year of The Artist functions in an

esthetic capacity, displaying allover abstract imagery in the background while the minimal text, seen first, is displayed prominently, demanding more involvement of the viewer, in order for them to understand the complex sequencing that is at its heart. And how does the sequence function? "1, 4, 12, 52, 365, 4,170, 8,760, 525,600 and 31,536,000— representing 1 year, 4 seasons, 12 months, 52 weeks, 365 days, 4,170 beverages (average number of hot drinks we each consume in a year), 8,760 hours, 525,600 minutes, and 31,536,000 seconds," explains Dom Raban, Creative Director of Eg.G.

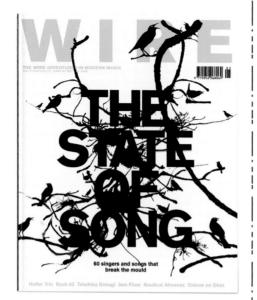

NON-FORMAT THE STATE OF SONG MAGAZINE SPREAD

This striking piece of all cap, sans scrif type really demands to be read first.

Not only does its weight, scale, and color draw the reader in, but its central positioning, its placement on top of fine black illustration, and its white background add to the density of letterforms and prominence on the page. After taking in this title, the next level to be seen is that of the illustration, the delicate detail of which gradually appears—more and more song birds become noticeable. The smaller, lighter paragraph of text is the third and final level to be seen.

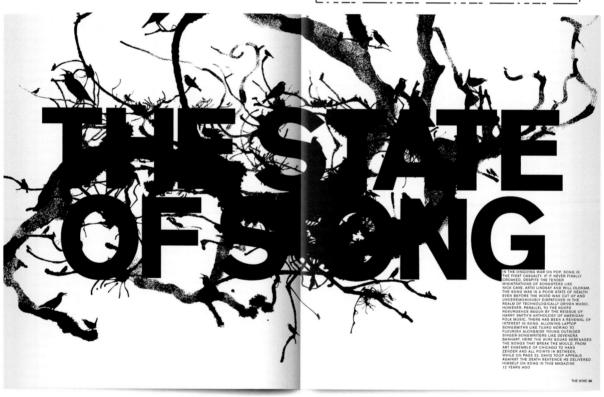

CLIENT	DESIGN	TYPOGRAPHY	
THE WIRE	KJELL EKHORN	KJELL EKHORN	
MAGAZINE	JON FORSS	JON FORSS	
ART DIRECTION	ILLUSTRATION		

KJELL EKHORN

ILLUSTRATION KJELL EKHORN JON FORSS

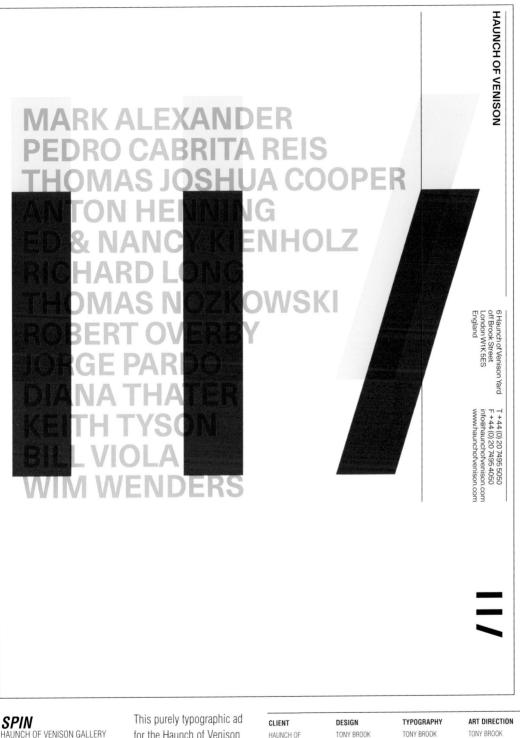

SPIN HAUNCH OF VENISON GALLERY PUBLICITY AND IDENTITY

for the Haunch of Venison show makes interesting use

of color. Text, in light cyan, overprints areas of the gallery namestyle. So what is seen first? If the reader were sitting in the optician's chair, should it not be the "black" copy on red? HAUNCH OF

VENISON GALLERY JOE BURRIN TOM CRABTREE HUGH MILLER

DAN POYNER

TONY BROOK JOE BURRIN TOM CRABTREE HUGH MILLER DAN POYNER IAN MCFARLANE IAN MCFARLANE

CLIENT
SMALL CITY
ART MUSEUM
COLLECTIVE

TYPOGRAPHY GILES WOODWARD KELLY HARTMAN

GILES WOODWARD KELLY HARTMAN

COPYWRITING DAVID GARNEAU ART DIRECTION GILES WOODWARD KELLY HARTMAN

DESIGN

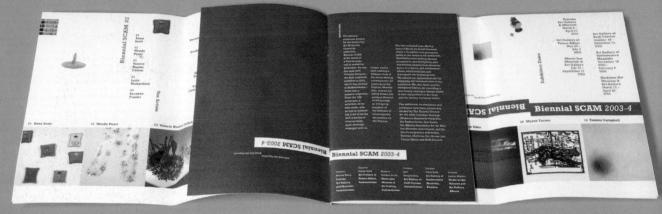

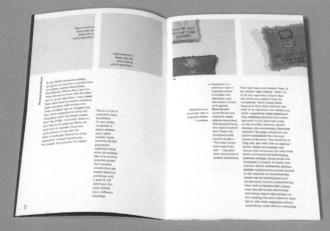

FISHTEN

BIENNIAL SCAM (SMALL CITY ART MUSEUMS) 2003–4 EXHIBITION CATALOG

This catalog was created by Fishten to showcase the work of 10 artists. The budget was limited, but all

work had to be featured in full color, extensive copy had to be accommodated, and details concerning a six-venue tour included. To overcome these challenges, Woodward and Hartman have devised a clever, full-color wraparound cover that doubles as a poster. This shows the work of all the artists, giving equal emphasis and weight to each.

The catalog itself makes dramatic and economic use of a single color. The opening spread has an impactive, solid red background that throws forward the white, slab-serif typography. Particular attention is drawn to the "Biennial Scam" heading that is positioned, on a white bar, near the bottom of the page. Contrasting with this, the next spread adopts the same unusual grid, but utilizes a white background with red text. Interestingly, although images are present within this second spread, their impact, due to halftone reproduction in single color, is very subdued.

Solomon Katz Distinguished Lectures in the Humanities at the University of Washington

Heather McHugh

In Ten Senses Some Sentences About Art's Senses and Intents Milliman Distinguished Writer-In-Residence

University of Washington

Ioman Katz Dislinguished Lectures in the Hu

Fri 27 Feb 7:00 pm Rm 110 UW Kane Hall

STUDIO VERTEX KATZ PUBLIC LECTURE SERIES 2004 POSTCARDS AND POSTERS

Studio Vertex have again produced a series of publicity cards for the

Katz Lecture Series. This set of three postcards and accompanying posters make distinctive use of bright color, type as image, and muted photography. Commenting upon the hierarchical aims of his designs, Lindsay states that "in this series, the client wanted to focus foremost on the speaker, title of the lecture, and credentials, followed by date, time, place, and then the Katz and Simpson Centre sponsorship." The objectives have been clearly achieved by changing the scale and color of type, placing the speakers' names in dominant positions, and adding muted photography in a recessive background layer. Michael continues, "The addition of photography creates more visual interest and brings forward the name of the speaker."

Solomon Katz Distinguished Lectures in the Humaniti

a core concensity of washington

Marjorie

9 MAX

Wed 19 May 2004 7:00 pm Rm 110 UW Kane Hall

Anthony Vidler

Reflections on Architecture and the Public Realm: The World Trade Center 1964-2004

Dean and Professor Irwin S. Chanin School of Architecture, The Cooper Union

Center for the Hur

Simpson Center for the UW College of Arty & S

Stanford University

CLIENT WALTER CHAPIN SIMPSON CENTRE FOR HUMANITIES **Design** Michael Lindsay

The Aura of Modernism

Sadie Dernham Patek Professor Emerita of Humanities

TYPOGRAPHY KAREN CHENG

COPYWRITING LESLIE JACKSON PHOTOGRAPHY LINDSAY, MARIANSKY,

PERLOFF

CUT-AND-PASTE VISUALIZING

It can be extremely difficult to achieve sufficient variety and

visual interest when creating different levels of information at the "thumbnail" stage of design. If sufficient accuracy and detail are to be captured, the mark-making process of pens and pencils is limited and very time-consuming. An interesting and unexpected alternative or addition to this initial stage involves cutting and pasting "found" samples of type and image into groupings and compositions, treating type and image in a comparatively abstract manner, and viewing the collaged elements for their qualities of texture, tone, and color rather than for making any literal sense.

In order to push the possible design options into less common and less predictable relationships, it is essential to collect a palette of samples, with a wide breadth of textures and tones, from a good selection of publications. Focus on relationships within groupings at first, and leave decisions concerning framing and ultimate scale until later. Ideally, there should be a correlation between the sampled text and image and the information that is to be included in a design: this creates realistic starting points for translating the thumbnails into the final design. It is important to appreciate that cut-and-paste samplings are likely to generate a wider selection of typefaces than will combine well in the final design. You must be prepared to rationalize; use the visualized material as an indication of whether to use a serif as opposed to a sans-serif font, and as a guide to leading. scale, color, tone, and positioning.

There is no doubt that this process of visualizing is particularly helpful in creating at least three levels of information. It will also assist you in developing variety within each level. Because of the assortment of source materials, even after rationalization, final solutions are likely to retain greater diversity and vitality. FIG.

Tooked sometimes at the her finger with her n three drops of blood fell How pretty the red bloo her as the snow, as rosy as the detailed with hair as black a black and with hair as black a

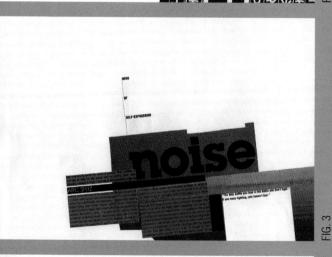

Hypothesis

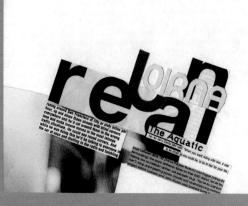

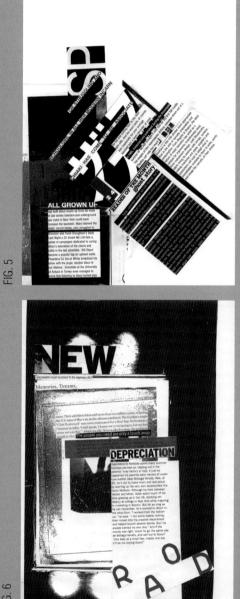

FIG. 6

This exciting selection of cut-and-paste visualizing evidences a number of design decisions that may not have been easy to make using pen or pencil alone, or, for that matter, by designing straight onto screen.

Looking at Fig. 7, combinations of cropped letterforms, lines, colored type, and image have been brought together around a striking angled axis to establish a dynamic and unusual layout. Clearly, the image and "New Serie" catch the viewer's eye first, with "LA prison psychologist ..." and the three lines of red, all caps, being seen next. The viewer is then left to access the remaining information. In each level there is variety and unexpected detailing that has been enabled by this hands-on process.

LA pitson psychologist with ten years

GRANT MEEK LAYOUT CONCEPTS

DESIGN GRANT MEEK TYPOGRAPHY GRANT MEEK

FIG. 7

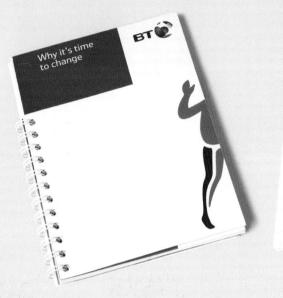

Heart

	Re M	
IN	0	
Ø (SDI	

١	Ne want people to believe that BT really cares
2	about and is committed to what it does.
1	This means that we need to believe in what we do,
4	and really want to make a difference.

1. I.C. e is 1 45 v. is

101 ...

11 .5 10 .5

40 ..

61

1 .

W. ...

10 .

6 20 6 ...

10 .

¢ 28

.

Brand Value eonle Val

Helpful

CAN YOU HELP ME ?

SURE

LEAVE TH WITH ME SORT IT O

I WILL

We want people to believe that BT listens and responds. This means that we all need to pull together, and to put our customers' needs first

Brand Value BT spest

People Value We pull together a to put the custome

SAS have produced this document to explain the shift in BT's brand values. The

blue section allocates a spread for each value, using large, bold type to make sure the main text is seen first, and remembered. Secondly, illustrated inserts, reminiscent of Post-it notes, are used to enforce each value. When turned over, these yellow sections allow the reader access to the text which is the third level in the hierarchy.

The final section in this design brings in real-life photography and the use of large areas of solid color. In the example shown, the reader cannot help but be drawn to the large area of bright red, and of course, the cute picture of the duck!

CLIENT DESIGN TYPOGRAPHY BT (BRITISH TELE-GILMAR WENDT COMMUNICATIONS)

GILMAR WENDT

COPYWRITING

PETE BROWN

ART DIRECTION GILMAR WENDT

SAS BT BRAND BOOK

ILLUSTRATION CHERRY GODDARD BT STOCK IMAGERY

PHOTOGRAPHY LEE MAWDISLEY

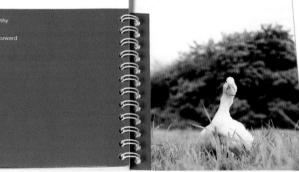

 CLIENT
 DESIGN
 TYPOGRAPHY

 JOHNSON BANKS
 MICHAEL JOHNSON
 MICHAEL JOHNSON

ART DIRECTION ON MICHAEL JOHNSON

THERE'S NOT MUCH DIFFERENCE BETWEEN ABYERTISING AND DESIGN. A TALK BY MICHAEL JOHNSON, JOHNSON BANKS

JOHNSON BANKS ADVERTISING DESIGN POSTER This poster, designed by Michael Johnson of johnson banks to promote his talk There's Not Much Difference Between Advertising

and Design, makes use of bright, contrasting colors, and bold, closely spaced, condensed type. The overlapping areas of the cyan and magenta letters are white, and stand out prominently from the black background. Using the principle of similarity, the reader is able to place all cyan letters together, creating and reading the word "Design." Following a similar method, they can then make out the word "Advertising" from the mix of magenta and cyan letters. Smaller, all cap letterforms are seen next, centered at the bottom of the poster, and these explain the theme of the talk.

Displaying the works of a number of artists, *Wall* uses a mix of imagery and type to capture the substance of each individual's

work. In each sampled spread, Lisa Thundercliffe has carefully crafted supporting text in a manner that is appropriate to the artist's work and interests. For example, on Nina Byrne's spread, type is mirrored, emulating this same feature within her shot of red roses in a white room. On Alan McGinn's page, Thundercliffe has selected a textured background and typewriter-style text to echo his fascination with mass-produced objects.

LIENT Aygood Allery Studios	design Lisa Thundercliffe	Typography Lisa Thundercliffe	Copywriting Lisa Thundercliffe	C4 Rajar Sonog Networking m	111	1	THE EMPLEMENT HADRI Marting WEODENDS OF An and WEODENDS OF An and WEODENDS OF An and WEODENDS OF An and WEODENDS OF A second second second A second second second second second second A second second second second second second second A second second second second second second second second A second second second second second second second second A second second second second second second second second second A second seco		
RT DIRECTION Sa Hundercliffe	illustration LISA Thundercliffe	PHOTOGRAPHY VARIOUS			A.S.		LAMPLE PREPARES L Henrickweise Antroise Roman auf Leistenang Martin (Leistenang Martin (Leistenang) Martin (Leistenang)		
								AS ALAN MCGI	
	3	for a qu	A COM A						
	- ay inter Receiption and th	auge i preate are m averyday sporience. est in the objects we tly I have been looking t as a way of looking he populous; that whi	Id stir sizen from that which This piece of work has deve choose to be associated wi ng at mass-produced objects at the relationship betwee ch is repeated and that whi	I see around me loped from my th. ; seeing the n the individual ch is unique.					
		A6 8A Nina Byrne ontware "Glimmer" 'norme A simple image of a single red use which inder south	milg'						
	T K	A simple strage of a to upon a his more accusate and a single red rose which estants in one control application, environment on the enginate of the strate of the strate and the walk of the enginate of the strate of the tests and the strate of the tests and the strate of the strate and the strate of the strate of of the stra	rizegia Nontrolado Parte Nontrolado Ser cavif Ser cavif Ser cavif		4	4	1.1	: 	

CL WA GA

AR Lis

CLIENT LINIVERSITY OF NORTHERN IOWA GALLERY OF ART

PHILIP FASS

DESIGN

TYPOGRAPHY PHILIP FASS

PHILIP FASS 2002 FACULTY EXHIBITION POSTER

In this exhibition poster, Philip

Fass has selected the numerals in "2002" as a vehicle to draw in the viewer. Although they do not present the most important information, their bold, large, pink type bleeds off at both edges of the layout to create an eye-catching, attention-grabbing centerpiece. Contrasting background imagery is grayscale and divided into three sections of varying scale; much smaller black-and-white type sits within horizontal and vertical bands. "The structure is a vertical triptych," says Fass, "and the rest of the typography forms a cruciform roughly in the middle of the composition. The design is meant to stop an individual drawn in by its boldness." Initially there appear to be only two distinct levels, but the viewer moves from pink type to the black and white level-horizontal text is read first, then vertical text --- and finally to the third level, the fairly abstract imagery that fills the remainder of the space.

This holiday newsletter and calendar from the IE Design team is packed with many diverse articles and

thought-provoking facts. Images are present very much to support copy and not to dominate, although it could be debated that the shot of the Chihuahua in the floral hat grabs the reader's attention because it is so unusual and unexpected. Articles make use of colored type, and changes of typeface, scale, and orientation to create fascinating variations of texture and tone as well as emphasis. Colored backgrounds in shades of blue and green help to divide topics and add more interest.

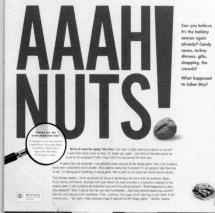

he

What is

CLIENT MARCIE CARSON

DESIGN

IE DESIGN + COMMUNICATIONS

COPYWRITING ART DIRECTION SCOTT FERGUSON MARCIE CARSON IE DESIGN TEAM

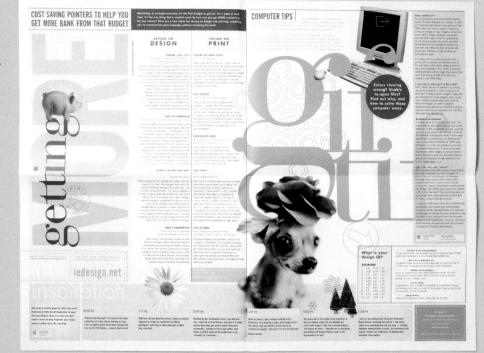

防药防药药药 ****** P

DANUARY

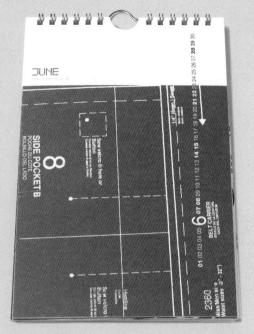

3 1 U IJ nn

NNNNNN 111111111

**

color blue, ranging through January's icy cool blues, April's numerous and diverse shades, June's denim theme, and July's blue, which is complementary to its orange background. In every instance the blue provides a cohesion that draws the viewer through the pages, with individual compositions and treatments configuring dynamic relationships that hold interest along the way.

BLUE RIVER DESIGN LTD. BLUE RIVER CALENDAR 2003

Exciting configurations of type command attention in the 2003 calendar by Blue River Design. Each page has a connection with the

CLIENT DESIGN TYPOGRAPHY BLUE RIVER LISA LISA THUNDERCLIFFE THUNDERCLIFFE DESIGN LTD.

ART DIRECTION	ILLUSTRATION	PHOTOGRAPHY
SIMON DOUGLAS	LISA	LISA
	THUNDERCLIFFE	THUNDERCLIFFE

กกกก

1 11 Pete Tong, Basement Jaxx, Norman Cook, Fergie, Judge Jules, Seb Fontaine, Dave Pearce, Lottie, Annie Nightingale, Rob Da Bank, Chris Coco, Tim Westwood, Fabio & Grooverider, Gilles Peterson Trevor Nelson, Har Mar Superstar, Dub Pistols, Dave Clarke Live, Adam F and special guests, Tula, Chungking & Freeland. For tickets & info: www.bbc.co.uk/radio1

CLIENT BBC RADIO 1

DESIGN ROB COKE

DAN MOORE

TYPOGRAPHY DAN MOORE

ART DIRECTION DAN MOORE

ILLUSTRATION DAN MOORE

PHOTOGRAPHY SHILA SULTANA

STUDIO OUTPUT LTD, Studio Output have used **VELIVE IN BRIGHTON**

AllWeekAllLiveAllOnRadio1 October27th-November2nd

> the unique outline style of neon lettering in their

BBC RADIO

identity for OneLive in Brighton as its connotations of lively nightclubs and current music not only create an appropriate character, but also attract attention. Dark backgrounds, emulating a night sky, throw out the text, which is broken down into a particularly eye-catching yellow, together with white, green, and blue. The outline lettering enables images of Brighton to be layered behind the words, and adds an element of intrigue to the designs as different elements come to the viewer's notice. The limited color palette then provides excellent coding for the large amount of information that has to be communicated in some pieces.

Consistent use of black plus blue or green type, along with white type reversed through blue or green bars, forms a strong hierarchy, as well as a simple system that categorizes information. Readers quickly learn to move from bar to bar to access the date headings, and only move onto the details below if they are required.

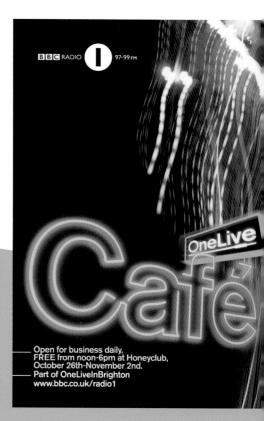

ndayOctober26ti n: The Car Boot Sale

m kits but backline & de be supplied). We'll also ha

- er29th: TheDa Ipm: One Lunch In Brighton
- n: Getting Down To Busin
- about how artists and Dis can kick off their c
- 3-5pm: The Dance Factory all material on CD please) plus advice from Seb For
- 3-5pm: Stick It On

ayOctober30th

- FursCayOccostroour -5pm: Vling ^{and} out about the art of 'club visuals' and have a go at creating your of
- ayOctober31st

(one an hour)

- m: DJ Q&A
- as to ludge jules and others

3-4pm: Last Chance Demo Listening Our last one-to-one demo & mix liste ek (all n

ndayNovember2nd m: The Fry Up

f the best of the week's local acts from the Café

Dance Producers me sessions may require booking on the day ase arrive early to avoid disappointment.

DOYLE PARTNERS

THE NEW YORK TIMES OP-ED "DISEASES"

This totally typographic piece illustrates the shocking statistics relating to epidemics worldwide, and is designed to help put the

SARS outbreaks of recent years into perspective. Disturbingly, the reader's attention is drawn first to the giant "Tuberculosis," with "Malaria" coming a close second; combine these with all the other dangers listed, and SARS is very clearly pushed to the bottom of the chart.

The sudden appearance of an epidemic typically inspires rapt attention, panic and action. Once the crisis subsides, public attention wanes atthough the threat of contagion	EMIC SCORECAR	By Howard Markel and Stephen Doyle Estimates of disease incidence and mortality are from the World Health Organization
the mise to contegration continues, especially among the world's poor. Compare our response to severe acute respiratory syndrome, or SARS, with the	NILLION NEW CASES	EACH YEAR 1 PERCENT of the WORLD BECOMES INFECTED with the TB GERM
more familiar germs that plague us daily. Compare it to the dangers of bad diet or getting in a car and heading out on the toad. Every life is precious,	OLUIUUGIG	INFECTIOUS DROPLETS TRANSMITTED BY: © BREATHING © COUGHING # © SNEEZING © EVEN SPEAKING @
but when you look at the numbers, SARS just isn't as formidable a threat as we've made it out to be. Its deaht rate is far lower than that for ADS and malaria:		O BE EFFECTIVE. TB DRUGS MUST BE Taken for six to eight months drug-resistant strains are incurable (and multiplying)
tend to be most active in the winter and early spring. In addition to taking the steps necessary exactly SARS at bay-watching	1 MILLION DEATHS A YEAR / 10-30 HEPATITIS puts you at high risk for cirrhosis, live	B VIRUS
out for new cases and isolating people who are contagious to others—we would do well to channel our energies into something more lasting: a permanent, Prevention (mesquito control)	LION DEATHS A YEAR A Multi INN NEW CASES A YEAR	No effective treatment. Vaceine can block chronic infection, but its high cost prevents its widespread distribution in poor nations.
is the most effective: JUU-JUU global public health system for the surveillance and prevention of the microbes that are certain to emerge in the future. Right now, worldwide accounting of disease is incomplete at	And Cardiovascular disease (heart attack and stroke) 5.5 million New Cases A YEAR 17 million NEAR	END OUD DEATHS A YEAR
best, hampered in large measure by sketchy reporting from developing countries. These gaps slowed our containment of SARS and allowed rumor	42 MILLION PEOPLE ARE H.I.VPOSITIVE Motorvehice Motorvehice 12.5 million Motorvehice 12.5 million 12.5 mil	MILLION NEW CASES & YEAR FIRELY PREVENTABLE A VACCINE THAT COSTS CENTS AND HAS BEEN AILABLE SINCE 1963
to spread more rapidly than reliable information. When the facts are few, it's easy for fear to fill the vacuum. Howard Markel. professor of pediatrics and communicable diseases	R DEATHS UCINE UCINE INFLUENZA A YEAR UCINE UCINE INFLUENZA 35 million new cases a year 200	LLOW FEVER DOO DEATHS A YEAR JOOD New Gases a year
the linvesity of Michigan, is author of the forthcoming "When Germs Travel."	ve NEW CASES FLAV LL	353 DEATHS out of 5.462 cases in 180 days

DESIGN

STEPHEN DOYLE

CLIENT

TIMES

THE NEW YORK

TYPOGRAPHY

STEPHEN DOYLE

ART DIRECTION

STEPHEN DOYLE

ninety nine percent of inspiration is...

gold ink is no more expensive than silver

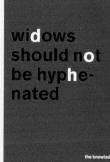

not heryan wills spencer buck

RYAN WILLS SPENCER BUCK

CLIENT

TAXI STUDIO LTD.

LS RY. BUCK SP

ART DIRECTION RYAN WILLS SPENCER BUCK

DESIGN

ALEX BANE

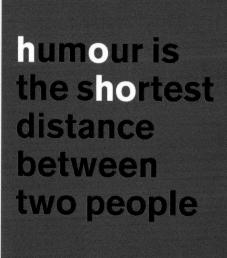

the knowledge

TAXI STUDIO LTD. THE KNOWLEDGE

Communicating Taxi Studio's knowledge of design in a witty way is part of the role of their corporate stationery. At present, 22 different statements, on 22 items of print, communicate company "knowledge" to clients. Each design, printed in two colors, uses type reversed white through a red background as a starting point. The reader cannot help but find themselves drawn firstly to this white lettering, which often highlights the subject of the quote, and then on to the complete statement, printed, with less dramatic contrast, in black on red. This work demonstrates the importance of recognizing the tonal values of colors; red is a bright, vibrant color, but it is also fairly dark tonally, enabling white lettering to contrast well with it, and black text to be clear, but not too powerful.

Lingh Geart Abbots Lingh Brintol and 36A Coll +44 (201275 399334) For +44 (201275 399344) Voir over Amstedes on sk

taxi studio Itd

if you don't see what we mean you're looking at it the wrong way round

the knowledge

the knowledge

do not apply wit with a heavy hand

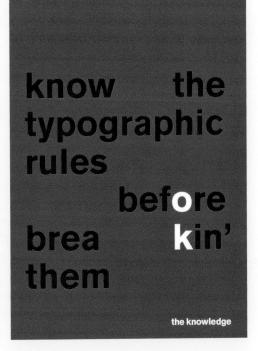

27 TYPE DRIVEN

This entirely typographic invitation makes interesting and unexpected use of

paper stock as a way of intriguing the recipient. The RSVP is the first thing the viewer sees, "so a course of action is laid out," says Philip Fass. "The text is divided into three parts: RSVP, to whom the rsvp should be sent, and the reason for the celebration. This sequence breaks up the information for the reader, while offering a rich visual experience." The metal grommet gives the reader final say over which of the three leaves of this piece they wish to prioritize.

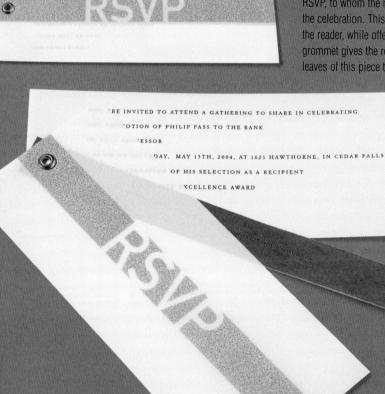

CLIENT PHILIP FASS

TYPOGRAPHY PHILIP FASS

COPYWRITING Philip Fass ART DIRECTION PHILIP FASS

DESIGN

PHILIP FASS

VISITINGARTISTPROGRAM ISASTRAUSFELD17SEPTE M B E R S T E V E N H E L L E R 16 O C OBERMILTONGLASER13N OVEMBERALLLECTURES BE GINAT630PMKATIEMURPH YAMPHITHEATERFASHION INSTITUTEOFTECHNOLOGY

PISCATELLO DESIGN CENTRE ITING ARTIST PROGRAM, POSTER

This poster by the Piscatello Design Centre

is particularly interesting with regard to the reader's perception. As the text is configured in capital letters, positioned on white bars, with the tops and bottoms of letterforms "bleeding" into a black background, the white counterform shapes are viewed first of all. These create a pattern that draws attention and, despite being difficult to decipher, is clearly recognizable as negative space between letters. Letterforms running onto new lines, regardless of word breaks, and without any word spacing, add to the abstract nature of the design, enabling only a persistent viewer to bring together words and shapes that form comprehensible information.

CLIENT FASHION INSTITUTE OF TECHNOLOGY NEW YORK

ART DIRECTION ROCCO PISCATELLO PISCATELLO KIMBERLY

DESIGN

ROCCO

PISCATELLO

+ CHUNG

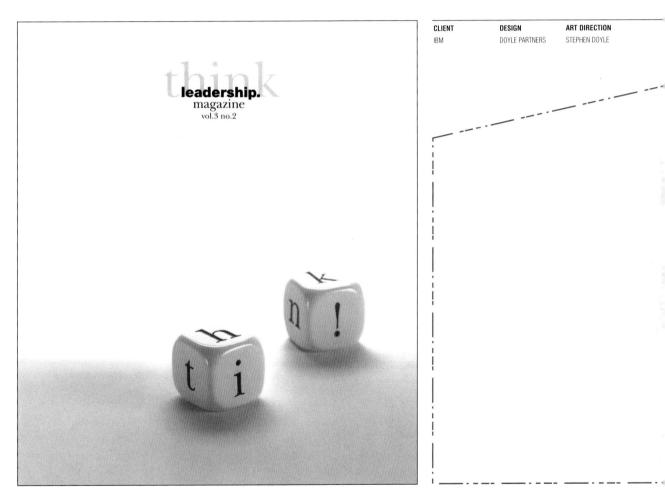

DOYLE PARTNERS IBM THINK MAGAZINE COVER

On the cover of this magazine for IBM, Doyle Partners took the corporate motto, "Think!" and etched the letters onto the

sides of two dice. Conveying the idea of risk in a playful manner, the resulting powerful shot ensures that the reader's attention is totally captured by these two small items. This is successful because of Stephen Doyle's brave selection of small-scale imagery, his positioning it at a distance from the masthead, and his use of generous space.

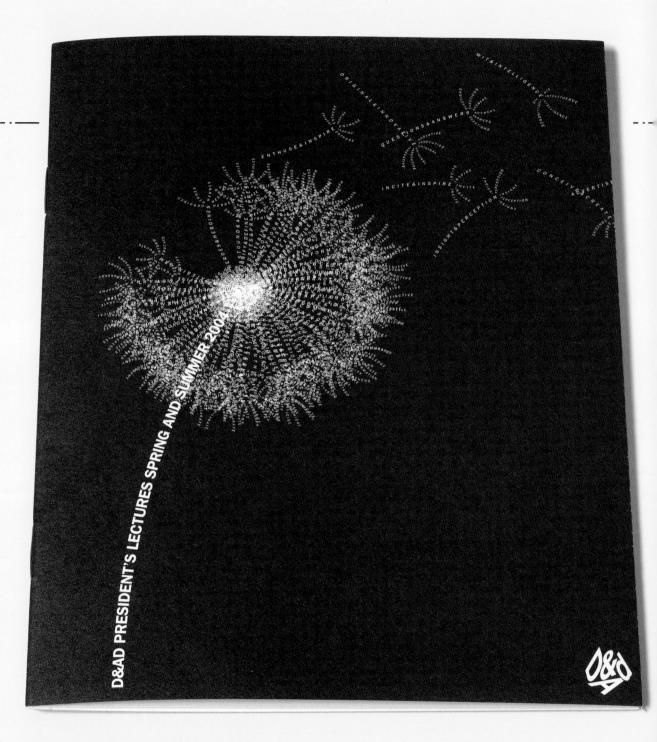

CLIENT D&AD DESIGN STUART RADFORD PHIL BOLD

TYPOGRAPHY STUART RADFORD PHIL BOLD FONTSMITH ART DIRECTION STUART RADFORD ANDREW WALLIS

RADFORD WALLIS D&AD PRESIDENT'S LECTURES SPRING AND SUMMER 2004 PROGRAM

Stunning typographic illustrations flow across the cover and flaps of Radford Wallis' design for the D&AD President's

Lectures program. The image of the dandelion clock and gently blowing seeds is made up entirely of lightweight, all cap text. Individual seeds are composed to make up words such as "insight," "inspire," and "enthuse." The cover, which has a glossy, yellow-coated interior, is printed on lightweight, uncoated stock. The inside pages, to contrast with this, use a weighty art board, but echo the inside cover with their subtle use of yellow. Hierarchically, the inside pages adopt the principle of proximity, discussed in Exercise Two (see page 36), to control the way information is accessed. Images, present on every spread, are printed in a light shade of gray, thus reducing their priority and impact.

EXERCISE TWO

PROXIMITY, CONTINUANCE, AND SIMILARITY

EXIZ

Appreciating some of the basics of visually sequencing information can be extremely

valuable. However detailed or sophisticated a design might be, basic principles of scale, composition, and spatial distribution are still undoubtedly applicable. In this series of exercises, the parameters of each section steadily expand to produce more complex outcomes. The emphasis is consistently upon the hierarchical structures, esthetics, and organizational systems.

There are three main principles of organization that significantly control the reading order of a layout: similarity, proximity, and continuance. Although these factors have relevance for imagery as well as type, they are particularly appropriate in the context of language and typography. Similarity relies upon a number of elements of similar visual appearance being perceived as having a common association. For example, type that has a similar weight, color, or scale, despite being dispersed across a page, will be seen as having a definite connection. Proximity is dependent upon compositional structures; when elements sit closely together, even though there may be a variety of weights, colors, and scales present, they are recognized as having a common connection. Implicit in this principle is the need for a certain amount of space to frame groupings of information. Continuance builds linear tracks in layouts to steer the reader through the text. Once again, variations of scale, color, and weight do not necessarily have an overriding effect upon the successful implementation of this principle.

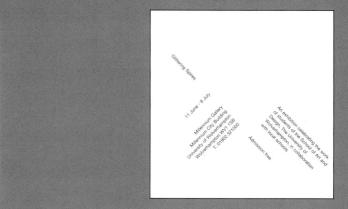

11 June - 8 July Millennium Gallery Millennium City Building Uriversity of Wolverhampton Wolverhampton WV1 1SB T: 01902 321000

> An exhibition celebrating the work of students of the School of Art and Design, The University of Wolverhampton, in collaboration with local schools

Admission free

Glittering Spires

FIG. 1 In fig. 1, only one typeface, weight, and point size have been used, forcing the layout to rely on composition. Groupings break the information into digestible amounts; a change of orientation prioritizes the most important facts, while the generous space in particular areas adds emphasis. A consistent approach to distances between elements creates overall coherence.

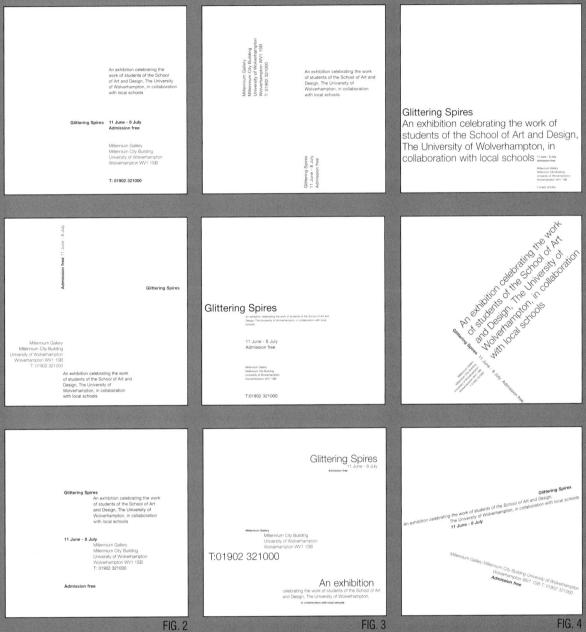

Fig. 2 demonstrates the principle of similarity in its most simple form, using one typeface, three weights, and one point size. Even though the bold type is separated by a number of lines of lighter text, the reader is drawn to each section of bold type in turn, before going on to access the remaining copy. Fig. 3 is an example of the hierarchical power made possible by the principle of proximity. Each typographic group utilizes a variety of different interpretations, and as a result of proximity, is accessed as a separate section of information. As a consequence, the viewer will complete one section before moving on to the next. In fig. 4, in spite of the combined varieties of weight and scale, the type is structured to form a linear force that guides the reader along the extent of each angled pathway.

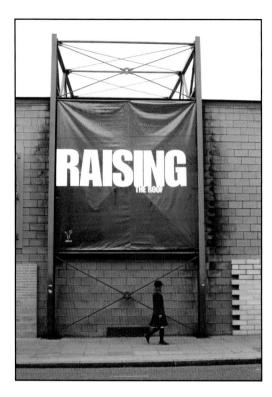

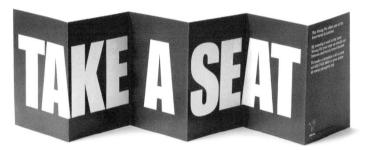

DESIGN

HENRY WHITE

COPYWRITING REBECCA FOSTER

HENRY WHITE DAISY DRURY ART DIRECTION REBECCA FOSTER

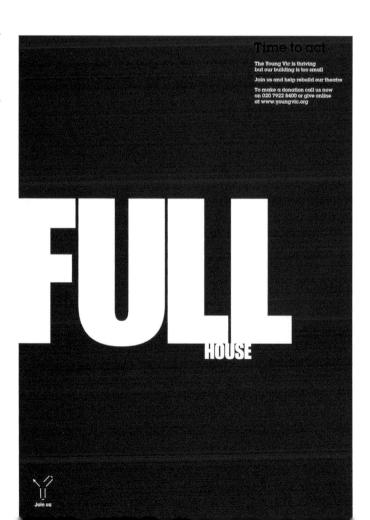

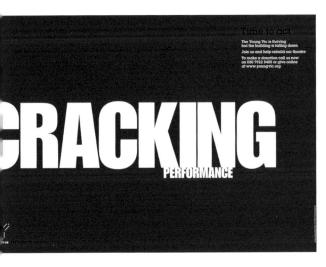

lime to act

The Young Vic is thriving but the building is crumbling Join us and help rebuild our theat To make a donation call us now on 020 7922 8400 or give online at www.youngvic.org

The aim of the campaign for the Young Vic theater was to bring a greater

awareness of the theater's desperate need for rebuilding, despite the increasing success of its performances. This objective was achieved in several ways. Firstly, the reader's attention is drawn to the large headline, which above is "cracking", and thus expresses the theater's demise. The reader is then drawn to the second word, "performance." "The combined words are taken directly from theatrical language, thus bringing together both the negative and positive situation that the Young Vic finds itself in," explains Rebecca Foster. "The third layer of text under 'Time to act' is a direct call to action," she concludes.

CLIENT DESIGN SHEFFIELD DOM RABAN UNIVERSITY

> TYPOGRAPHY DOM RABAN

ART DIRECTION DOM RABAN

the encount in an advance in the Table State of the State

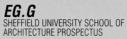

Hierarchies are relative in every sense, and although the typography within this design is not particularly dominant, because the

context is a prospectus, the viewer focuses on the text. Changes in the angles and orientation echo the structural nature of architecture, and blocks of color, based on a grid derived from Fibonacci rectangles, are seen predominantly as "vehicles" for type.

CLIENT AIGA LOS ANGELES DESIGN STEFAN G. BUCHER

TYPOGRAPHY STEFAN G. BUCHER ART DIRECTION STEFAN G. BUCHER

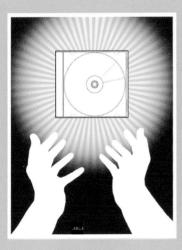

344 DESIGN, LLC AIGA LOS ANGELES SOUNDBLAST EXHIBITION POSTER Making use of three-color print, this poster for Soundblast, an exhibition

of entries in the AIGA competition for CD cover design, dramatically captures attention and emulates the effect of different levels of music. Type runs upward at an angle, evoking pitch and volume, with large, all cap headings being the first point of focus. The largest instance of the heading "Soundblast" is captured in light yellow and positioned upon a slightly darker yellow background; whether it is perceived as letterforms or space, the yellow acts as visual glue to hold all the elements together, and ensure that they are read.

As a private research university, **O** These advantages are not always found at other institutions: smaller classes, an extensive alumni network, undergraduate involvement in research, flexible academic programs and opportunities to interact with our faculty and staff. These are just, a few of the many reasons that make USC an institution worthy of your educational investment.

CRASSIANTEE FROM ARCOMD THE WORLD. The UNA source ID description are going and an encodered and a structure of the structure are the large and an encodered data introd. We conservative are well to the structure of the structure of the structure are the large and an encodered data into the structure of descriptions are the large and an encodered and the Structure of the structure of the structure are intermediated and encodered metality intermediates. Name Annealment and encodered metality intermediates are intermediated in multiconferent metality intermediates and encodered and an encodered metality

COMBINE ENGINEERING WITH... In violations to its randingsing indigenergy despice programs, the School encourages audions to encounted a summer or even a doublemore into engineering. The data such as Chartera Television. International Relativistics, Encouramental Studies, Buriness on Charles Manufactures, Encouramental Studies, Buriness on Charles Manufactures and the School of Engineering strongly interdisciplinary educational opportunities, and we helieve these experiences help shape our students into well-rounded engineers. Our degree programs will prepare you to enter the field of engiceeting immediately after gradiation, or to units. Field of engi-

Qualified automa also have the option to participate in our combined B SANK 60 vegets regimmenting routinous. CHOOSE A MAIOR OR EXPLORE LNC indexts become part of our engineering commonity their very flore someters. You can apply for a specific traditionering impair from seven different departments that other another than the hadron.

legare programs and options, or you can apply can all indecland captorering many. As intro-you emplored in trade-tand a manufacture constraint and a straint and a straint and all world problems and obtain hands-on experience. If she all world problems and obtain hands-on experience if she obtain a straint and a straint barrier and straint and decler to begin as an undeclared engineering mytion, you woll due ENGR 101, a gateway course designed in introduce you Les Angolas is une el tito most inna inte deart of bio eny anones a u interational, collinai and comunar the eny aten permiter separar el

(init any and parameter standards to an all the generator suscensessing of neutronlayer reduction within y on the work to a different condexis, capacitable suspervisions, and advancement in series right is communication, exists/someri statistication advancement in series right is communication, exists/someri statistication instruction advancement in the series of the series of the series of the immunication advancements. The advancement advancement advancement matter of anothering, in france disappending the series advancement advancement matter advancements. For advancement advancement advancement advancement advancement advancement. The series in the disappending to the disappending to the series of the series of the series of the series of the disappending to the disappending to the series of the series of the series of the series of the disappending to the disappending to the series of the disappending the series of the

vereleval, surf den heint, Beler modenti folies into the Santa Monita resourchains, share stown it explanate at teacia Beler, sonietes of Cassissa Istand, go nich Clobbing at Japhia Thee Billman Red, how marked famous ourservin, insert vestet clobers provide to fairt relacion the Januathy grounds of the USC campus.

offers many advantages.

to all the engineering disciplines offered and to provide you with a team building experience such as designing a simple tobot. Our Freshmen Academy program also provides you with the opportunity to explore the societal and ethical impact of engi-

GET TO WORK AND GET INVOLVED (SC provides a worldh of resources for the enhancement of students alternative and worldh of resources for the enhancement of students

In onborner annhands' intelligitud growth, the Unitednety provides variety of specialized libraries, computing context and research entrers. High speed etheretes lines in every comput housing genes when a second second second second second second sections throughout campos keep you connected wherever you are on campos!

Within engineering, you can choose to become involved in one of vers 2. Sequencing students requirements, productional engineering societies and engineering howners vocierises, se out a participate in many other opportunities loke our memory parging, free-studing, or pilo and Watenes Vinterees Network, Engineering thateses on allow sinds on their professional proviby initiating the resources offered through both Engineering (accurs Services and the compressively Carter Planning and

In addition, namy other opportunities for social, personal and spiritual growth can be found at USC. There are over 500 student organizations, recreational and sports activities, solunteer opportunities and reliations realizations on someone

IE DESIGN + COMMUNICATIONS USC SCHOOL OF ENGINEERING VIEWBOOK

The USC School of Engineering viewbook is a 32-page, full-color brochure that, to quote Ted Cordova of IE Design, "breaks down a massive amount of content, and creates a typographical hierarchy that organizes this content effectively." Designer Marcie Carson has derived a flexible, six-column grid

that functions in varied and interesting ways. Using a mix of serif and sans-serif type, pages have a lively, interesting, and accessible feel that encourages the reader to select small, highlighted areas of information, and to dip in and out of copy. Images obviously play a significant role in these pages, but many have been carefully subdued and knocked back, with the aid of tinted panels.

intain aic w

Environmental Engineering

Environmental engineers enhance our quality of life. They Environmental engineers enhance our quarty of the, they treat and properly dispose of environmental pollutants, develop techniques for improving our air, water and soil quality, oversee resource recovery and recycling methods, create "green technologies" used in consumer produers and manufacturing, and administer environmental regula-tion of the source for the source of the protection of tions to ensure the safety of humans and the protection of

CURRICULUM

MAJOR EMPHASES AND OPTIONS

ology emphases will provide a background in scientific a

MINORS

USC is a premier research institution that also values the importance of providing students with meaningful hands-on professional experience related to their chosen field of study. Additionally, we are not only committed to helping our students succeed during their time in college, but we are also dedicated to providing resources that will assist students with their posternaduate plans. with their postgraduate plans.

ENGINEERING CAREER SERVICES

Light success (IPL)

NG CAREER CO

ENGINEERING CAREER EXPO

PUS INTER

CLIENT USC SCHOOL OF ENGINEERING

DESIGN MARCIE CARSON

CLIENT	DESIGN	TYPOGRAPHY	
THE WIRE	KJELL EKHORN,	KJELL EKHORN,	
MAGAZINE	JON FORSS	JON FORSS	

ART DIRECTION Kjell Ekhorn, Jon Forss PHOTOGRAPHY MAGDALENA BLASZCZUK

Founded nine years ago in response to bad European attempts to mimic Anglo-American rock, Austria's Mego label have helped define the growth of experimental electronica in the 90s and beyond. In Vienna, Edwin Pouncey meets the table's inner circle, Ramon Bauer, Tina Frank and Peter Rehberg, to hear about the label's past. reserved and future Photos Macadeana Blacemuk.

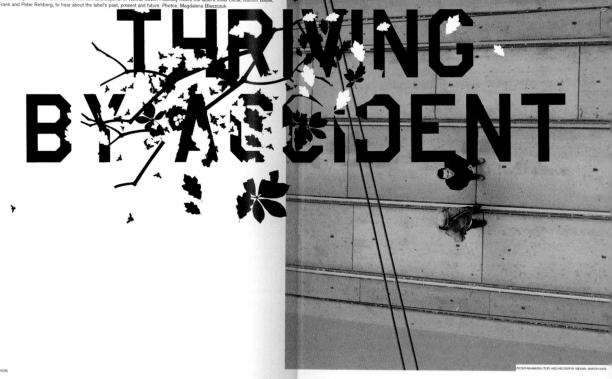

NON-FORMAT MEGO LABEL MAGAZINE SPREAD

Using bold, centered, illuminated letters for the heading of this spread for

The Wire magazine, Kjell Ekhorn and Jon Forss have commanded the viewer's attention. Although 50 percent of this spread features an allover image, the reader is drawn to the heading first because the shot, captured from an interesting angle by Magdalena Blaszczuk, has slightly lighter tonal values and the detailing of the lettering is so unusual and unexpected. Three long lines of small text on the left-hand page make up the third level of this "sandwich."

MUGGIE RAMADANI DESIGN LAB REBEL HAIRDESIGN IDENTITY Heavily outlined, Gothic-style type forms the basis of Muggie Ramadani's new identity for Rebel Hairdesign A surprising identity for Rebel Hairdesign. A surprising

mix of yellow, green, gray, and black has been carefully selected to ensure that the company namestyle is always seen first, even when placed on top of Mikkel Bache's color photography.

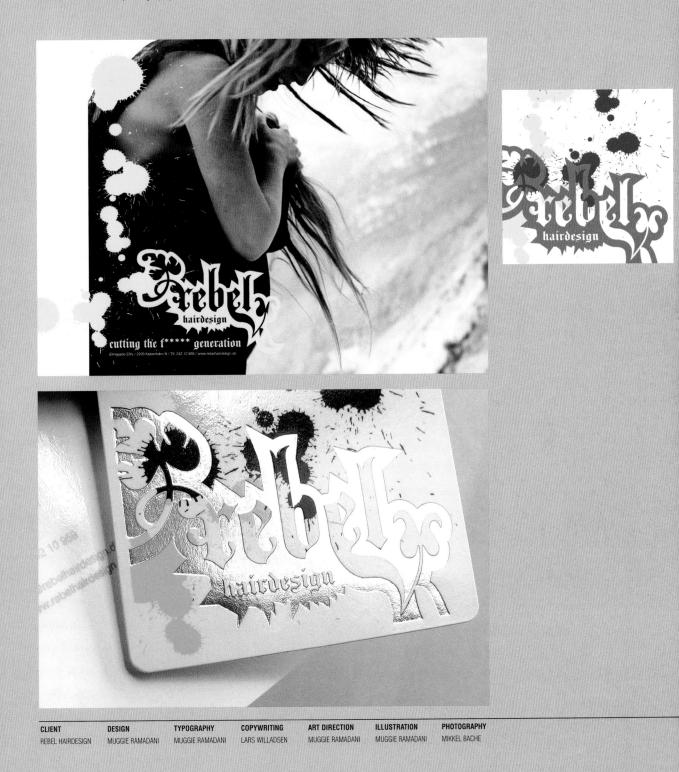

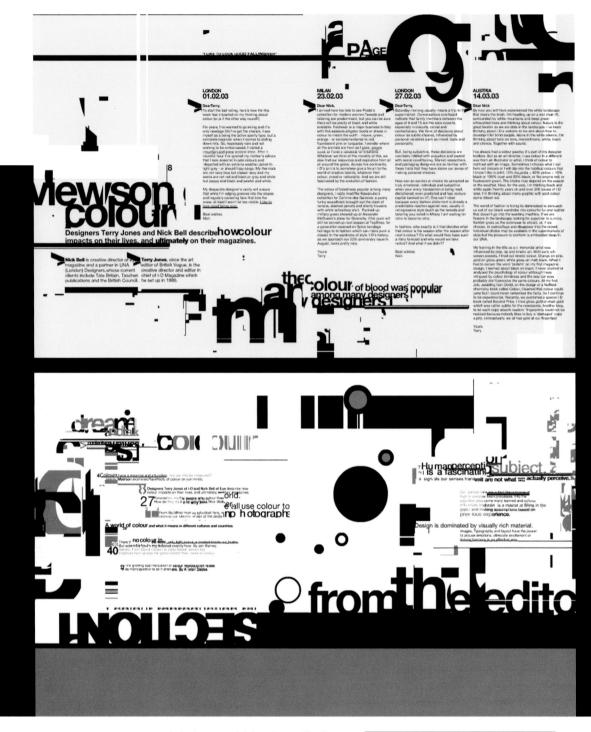

MATEEN KHAN DESIGN DREAM AND TALK

A single, strong, bright color, working in tandem with black and white, makes each of these pages visually dynamic and eye-

catching. Type is configured as text and image, and is predominantly in black, making the large-scale letterforms extremely powerful and inviting. Because certain large letterforms come together to form recognizable words, the reader expects all the sections of letters and graphic shapes to have meaning; as a consequence they entice the eye around the spread and into the copy.

CLIENT SELF-PROMOTIONAL PROJECT DESIGN MATEEN KHAN

FISHTEN NEW PAINTINGS EXHIBITION CATALOG

"A white-on-white typographic concept has been chosen to mimic the architecture within the gallery," says Giles Woodward of Fishten's design

for the Robert McLaughlin Gallery. "Light, shadow, dimension, and space are created by the use of gray ink, clear foil, gloss varnish, and blind embossing," continues Kelly Hartman. This ensures that, following the wishes of the artist, Gary Spearin, the function of the installation is present within the catalog. "Hierarchies were developed by mixing special effects together to create coded information, a concept also inherent within the artist's work," concludes Hartman.

CLIENT	DESIGN	
ROBERT	Kelly Hartman	
MCLAUGHLIN	GILES WOODWARD	
GALLERY		
TYPOGRAPHY	COPYWRITING	
Kelly Hartman	IHOR HOLUBIZKY	
GILES WOODWARD		
I I		
ART DIRECTION	PHOTOGRAPHY	
Kelly Hartman	GARY SPEARIN	

IDENTIKAL IDENTIKAL SHO

The Identikal shop. designed by Identikal's Adam and Nick Hayes, is a

colorful, animated Web site that comprehensively showcases these identical twins' contemporary type designs.

The Home page banner allows the visitor access to the four main areas of the shop: fonts, products, sounds, and visuals. This banner, teamed with the strong, iconic namestyle for the shop, plus log-in and search options, has a constant dominant position at the top of each page.

The site expands to reveal a fascinating, tantalizing mix of typeface samples, many shown using a limited palette of two colors. Each face has a clear identity of its own which, with the aid of clever animation, calls out to be viewed in direct competition with its neighbor.

SHOP

121:05:2004

THE IDENTIKAL FOUNDRY SHOP

RODUCTS)

FRANKU

a-F%\$

anton

HLEN

TΔ

6 FURT FRITTELS 81

K HERE TO VIEW

D

OUND

.

MAS

6 CONTEA

S FONT FR

Podiur

VISUAL

IT 2 J P TI

5010

T≏

C

£89

8.0

£109

0

FONTS

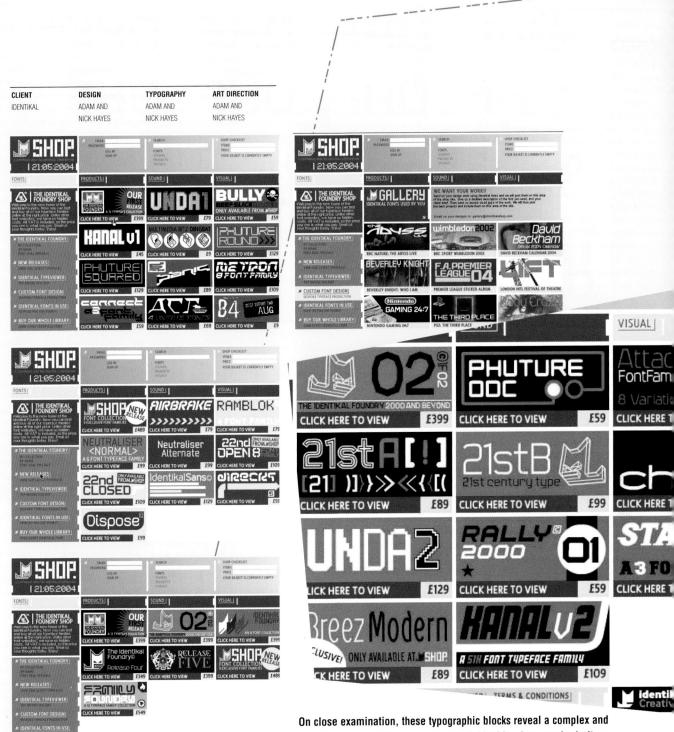

On close examination, these typographic blocks reveal a complex and expertly controlled hierarchy. Each individual box has equal priority on the page, while adopting changeable use of color, scale, and weight. Color priority is intelligently varied, but controlled to guarantee the visitor unbiased, fair access to all typefaces.

CLIENT	DESIGN
ROCKPORT	STEFAN G. BUCHER
PUBLISHERS INC.	

COPYWRITING ART DIRECTION STEFAN G. BUCHER STEFAN G. BUCHER

344 DESIGN, LLC ALL ACCESS: THE MAKING OF THIRTY EXTRAORDINARY GRAPHIC DESIGNERS groupings, and exciting use

FIRS

IMPORTANT INFORMATION

TYPOGRAPHY STEFAN G. BUCHER

of space epitomize the pages of All Access: The Making of Thirty Extraordinary Graphic Designers by Stefan G. Bucher. Bold, sans-serif, all cap headings draw the eye on most pages, providing an authoritative starting point for the viewer. A mix of cut-out and squared-up images are used within spreads, with the addition of vertical and sometimes horizontal rules to anchor these shots to the bottom of the page, and visually link them with the text.

AND

KIOCK

Itegrated her love for graphics with an ever-growing interest with an ever-growing interes in furniture design to forge in turniture design to torge a unique body of work that benefits from its exposure to both worlds.

AND THE CLASSICS NO

K

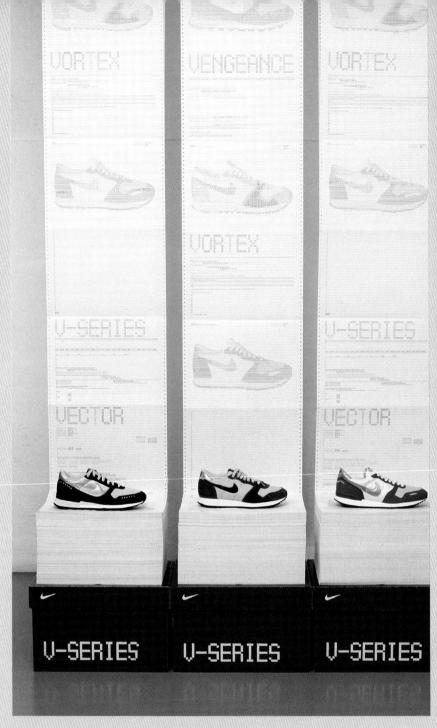

	S.		BR	TE
	U-SEF	BIGE	C	
5	~	-	-	

CLIENT DESIGN NIKE JOE BURRIN

TYPOGRAPHY JOE BURRIN

ART DIRECTION TONY BROOK

Connecting well with eighties' style, Spin have used ASCII type and reams of computer paper to establish an identity for

its V-Series trainers, first created by Nike in that decade. The typography evokes "old-fashioned" computers, and examination of these reams of paper not only provides information concerning footwear, but also line upon line of characters that come together to create images of the shoes themselves.

TECHNICAL STAFF 5:20AM FINAL CHECKS ARE MADE FOR THE BUSY DAY AHEAD

A NEW DAY BEGINS

Despite strong photography, condensed,

be seen by readers on each page of A New Day Begins ... The central position of the title on the front cover establishes an eye level that is maintained across each spread, linking them together and ensuring that the headline type is read first. Large, bold, introductory text and a mix of full-color images are the second element seen, leaving the silver body copy and small captions to make up the final layer of this "graphic sandwich."

CLIENT	DESIGN	
LEEDS BRADFORD	LEE BRADLEY	
INTERNATIONAL	DAVE WATERS	
AIRPORT		
TYPOGRAPHY	COPYWRITING	
LEE BRADLEY	JOE COLEMAN	
ART DIRECTION	PHOTOGRAPHY	
LEE BRADLEY	MICHAEL FEATHER	

BRAHM DESIGN FOOTBALL & FORTUNES BOOK DESIGN

Brahm Design have adopted a strong use of color and large headings for the

pages of Football & Fortunes. Section dividers are color coded, with color selected to tone with the hues in the photographs; this not only gives cohesion, but also takes the reader comfortably from large, dynamic expanses of color that contain the type, to similar colors in the image. Brahm have created a simple grid structure and a clear typographic hierarchy throughout, with main headings, subheadings, quotes, and body copy in two weights.

Cities United

Nothing could have prepared me for my first Saturday at the Pools. With all the post opened, hundreds of women reached for their 'Joey' machines to security stamp the coupons. The noise was thunderous." Welcome to the computer age

The images of hundreds of women working in next rows of delets to detek and buble check each and every coupon are synonymous with Littlewoods Photis, us they hist the technology that was necessary to keep pace with the growing popularity of the pools in the last Phota and says (Pols), there were no suit on to be processed and the second process that the power is built and process on the last Phota and says (Pols), there were no suit on to be processed and the second process that the power is built and be processed and the second process that the power is the the 1998. Inverse, as women than 10,000 staff.

25

one then investment with the service of the service

Millions of customer addresses stamped roth secarate stimoles – and service up thousands of searate field of storing space – were replaced in 1954 or magnetic taples capable of hoding more than 200,000 addresses on each space field. Interecosts became one of the company private shares installed an BM 360 system, one of the most advanced at that there and bio coper with the customer database of over 10 million propions when A year later, Littlewoods became the first company in the UK to related in copies of the relation relation that advanced det coupsers to be determined and customer tables and the standard database of the to related in copies of the relation relation that advanced det coupsers to be determined and customer standard standard the standard database of the coupsers (bio bedieved the customer standard standard base).

ande sa vizikor, Hub Aviervie Reple

04 Millionaire Maker

All the definition of the defi

ne atera	ris willin, Mary, was talled in workf come into moning inconting in Knamethome incident. The furthers word to be right as Jose social to be right as Jose social to be right as Jose social to be right and the horizon program when all the right function.	
teller pro	und to be right as Joe. police sergeant from Edyth	
a chinaut Irom Ko	i for 1261,742 in 1977 als star Tolly Savalar.	
Constants Constants Constants		An entropy or an entropy of the second secon
		The state same of a same from the second
		Editors dock workers Harry drift in Mathematics Co. 255, 387 for their P materials 1, 1984, 7the former and late
norman and	where Carson and Cal	Spage, Horn Harwesh, Isail Reserves the period for 20 years last load as the second second period as the second
David Pro	- Sent insertion, and the sent insertion of the sent inserting of the sent insertinge	Chaine discle vertices Henry and Di Making was Sci265,887 for their t states in 1984. The time at states in 1984, the time and the spaces for the time and a part of the time the provide of a part of the time and the time and the part of the time and attribution of the time and the time and and an another time and attribution of the time and part of time and part of the time and part of time an
hutery/file with the	nchers rund been chorum hers of a sping of white	The checker was hardfold over by lonner Chevrol 1 The Broats concentres Chevrol 2 The Broats
on holide Michael I	y in Spont. To personality Automotic personation the	

CLIENT LITTLEWOODS POOLS TYPOGRAPHY PENNY LEE LEE BRADLEY

COPYWRITING PHIL READ ART DIRECTION LEE BRADLEY

DESIGN

PENNY LEE

CLIENT PROMOTIONAL PROJECT

DESIGN MATEEN KHAN TYPOGRAPHY MATEEN KHAN

ILLUSTRATION MATEEN KHAN

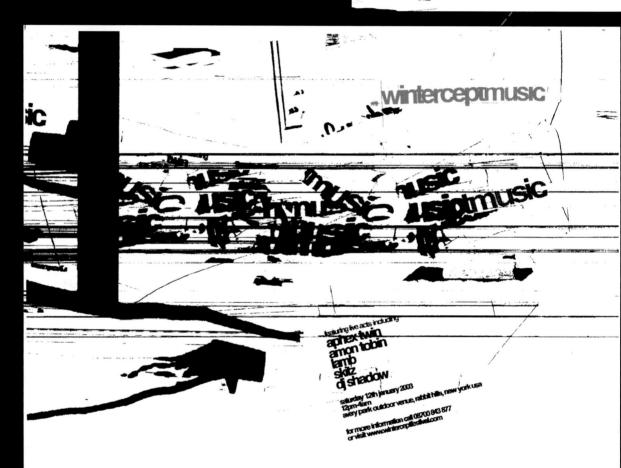

MATEEN KHAN Mateen Khan has used DESIGN typography as the WINTERCEPT MUSIC FESTIVAL POSTERS predominant feature in

these posters for a music and snowboarding festival to try to capture the exciting speed, action, and culture associated with the sport. In a sense, the type borders on image, but because there are no figurative elements, the viewer can only bring the letters together to make words. The secondary text then becomes a natural progression.

MIRKO ILIC CORP. MOVING CARD

A palette of orange, yellow, and green vellum immediately entices the viewer to look more closely at this unusual yet simple

moving card created by Mirko Ilic. A repeated L shape, which is the Levy Creative Management logo, is recognized next, as form and counterform interact with each other. Black type then anchors the piece, confirming its purpose. The mixing of colors in each announcement, and the movement of the Ls in their envelopes, provide an additional and final level of experience that leaves the viewer with a sense of fun and spontaneity.

CLIENT	DESIGN	ART DIRECTION
LEVY CREATIVE	MIRKO ILIC	MIRKO ILIC
MANAGEMENT	HEATH	
	HINEGARDNER	

CLLM	D-SI	ETA AS	うち して
	TO BLEE		
CD COVE	R. COLD		

This entire collaged design by

Stefan G. Bucher of 344 Design evokes the quality of a well-used scrapbook with a decorated cover. The name and logo of the band are shown as stickers, and all supporting text and information appear as separate, glued-down pieces; these attract attention in varying degrees. All type styles have been carefully selected to produce a deliberately convincing amateur style, and yet it is clear that the hierarchy is professionally controlled, and totally appropriate for "someone obsessed with blood," says Stefan.

> CLIENT DESIGN TYPOGRAPHY ART DIRECTION GEFFEN RECORDS STEFAN G, BUCHER STEFAN G, BUCHER

FISHTEN BLIND STAIRS EXHIBITION CATALOG

Fishten have created an instantly evident staircase effect with their unusual

format for this catalog for the exhibition Blind Stairs. Divided into three sections, imagery is restricted to the bottom step, while biographies and essays are accommodated within the pages of the upper two steps. The cover takes its theme from the concept of blindness; the hierarchy is controlled through the use of two colors of similar tone that make the text less distinct, and by partially obscuring the typography. Interestingly, although the partially seen type says something about the experience of being blind, from a reader's point of view, it also attracts attention because it is unusual. Inside, text-rich pages gain impact through the use of single colors—red and blue—printed on pale stock, and headings develop the blind theme by being partially obscured along an angled baseline.

The idea of Blind Stairs began with Janice Gurney. Mary Scott and Arlene Stamp. As Janice explained in a letter. Arlene, Mary and I feel we are at similar polinits in our lives as arists. All of us are revisiting our past work and remaking it in some way that alters its original form and content. The exhibition grew from the rather open proposal assembled by the artists in 2001, and became the travelling group retrospective that opened in Halifax, and later in Lethbridge, in 2003. We have kept the original title, Billod Stairs, which the artists arrived at Jointly, and also the emphasis on patterns of appropriation that mark their conception of artistic authorship. CLIENT SOUTHERN ALBERTA ART GALLERY

COPYWRITING

EMILY FALVEY

SOPHIA ISA.IIW

DESIGN GILES WOODWARD KELLY HARTMAN

PHOTOGRAPHY

TYPOGRAPHY

GILES WOODWARD

KELLY HARTMAN

ART DIRECTION GILES WOODWARD KELLY HARTMAN

ANDY PATTON JOHN DEAN J. RINGUETTE EDMONTON ART GALLERY PETER MACALLUM CHRIS THOMAS KEVIN BAER

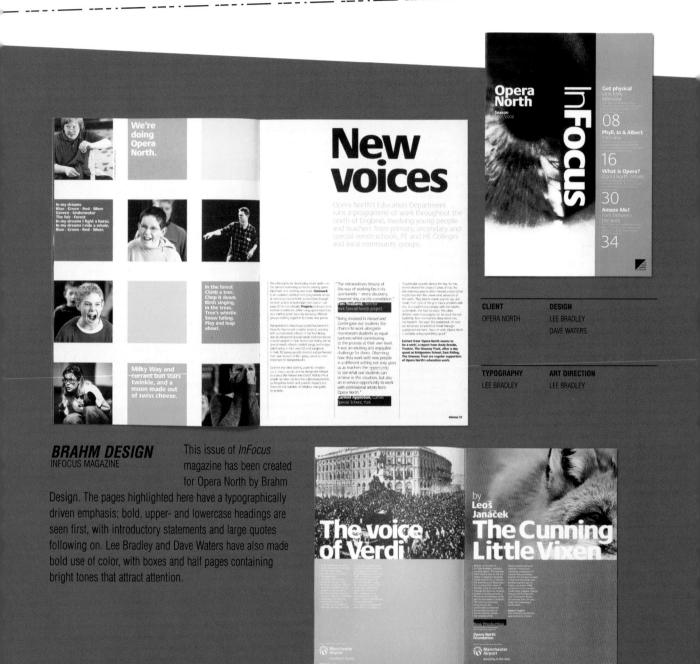

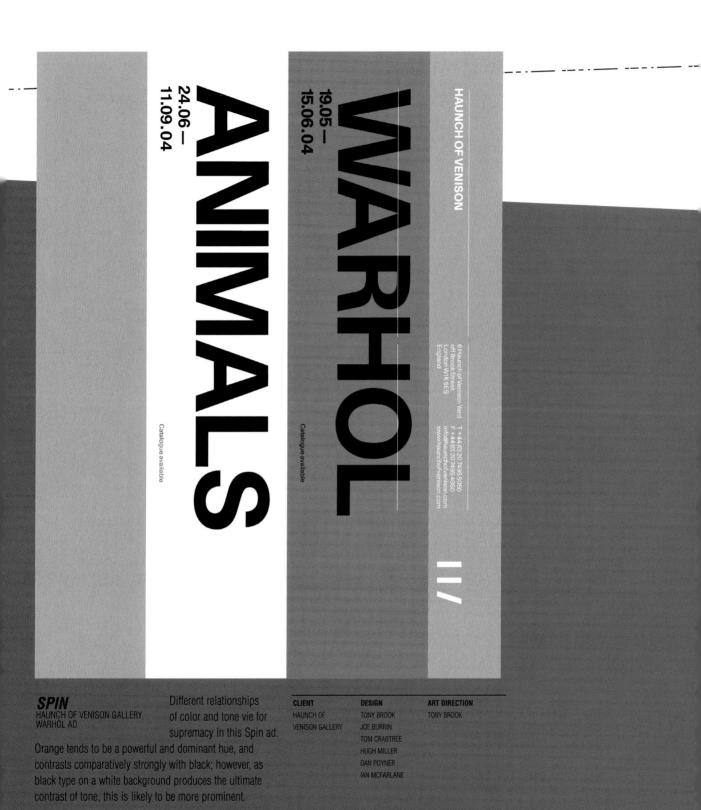

SEQUENCING

Large quantities of type can be **OUANTITIES OF TEXT** daunting if designers do not take responsibility for breaking information down into different

> **TYPOGRAPHICALLY DRIVEN** HIERARCHIES

levels and groupings. This exercise gives you the opportunity to explore various ways of providing the reader with at least three levels through which to access information: initial headline copy to take in at a glance, a second level that elaborates to some degree but can still be absorbed fairly quickly, and a third level that fills in details.

Unfortunately, the middle layer is frequently omitted or underplayed. This exercise encourages the handling of this "middle" section so that it not only leads the submissive reader through the text in a set order, but also holds the attention of more resistant viewers, and keeps drawing them back in. Working with the same text each time, produce a broad range of alternative A4 $(81/8 \times 1111/16in/210 \times 297mm)$, double-page layouts that include at least three levels of information. Priorities do not need to change, although they can, but the ways in which these priorities are achieved must show variety.

Fig. 1 shows the use of comparatively simple design devices to encourage the viewer to continue on through all of the copy. Bold headlines attract attention initially, then the bold, exdented start of each paragraph, together with small sections made bold for emphasis, draw the viewer through the text.

Fig. 2 uses white type on black boxes to create a strong second level. Gray highlighting, imitating the use of a highlighter pen, emphasizes random areas and entices the reader back into the bulk of text repeatedly. Compositionally, the black boxes lead in from the left, down to the base of the layout, and finally off to the right, persuading the reader to absorb all the text "en route."

Fig. 3 introduces typographic variations that make the middle levels of information guite challenging for readers. Close leading, changes of orientation, reversals of white through gray, and black on gray create a more interactive environment that tempts the viewer to delve deeper.

In each layout, white space, paragraph and line spacing, and gutter widths are all used to determine the paces and rhythms that help to maintain the reader's attention.

TYPOGRAPHICALLY DRIVEN HIERARCHIES

EXAMINING THE FASCINATING AND COMPLEX REALMS OF HIERARCHIES THAT ARE TYPOGRAPHICALLY EXPRESSED

Payments in the angle of the second s

Includes wai of thereos. However, the second secon to "work their way down" a layout.

SITION AND ORIENTATION THIN A LAYOUT HAVE FAR SS SIGNIFICANCE THAN NSITY OF TEXTURE AND RENESS OF TONE; KEY FORMATION WILL STILL BE

It is important to recognise that all typographic bonal and textual againes are relative, both to exch other and to the supplementary test and major on the pope. Composition isotrably has covered influences, galors acrowed type will be to both both the section of the section of the pope dotted both that and the poper on the exception of the tope of the section of the section of the section of the pope poper test and even the section of the section of the pope test is marked and below of at the parameters of the pope space and the readers is attention will and containly be dates to its data for containing operations and and the readers is attention will and containly be dates to its data for containing and containly be dates to the readers is attention will and containly be dates to the readers is attention will and containly be dates to the readers is attention will and containly be dates to the data and major. Tangets not de associated the readers is attention will an early the dates to the second second the second second the integers of a serial cone, or interview the integers of a serial cone, or interview the integers of a serial to account.

alrages with the picture content.

to the selection. To the selection of t attract or deter

The inclusion of color in a levoid brings another dimension, another modifier, to the ordering of visual data: luminosity and vibrary are entering; softer judic colors append to be innoised back; certain colors have connotations that provide meaninghal relevance; small amounts of colors and as hybridgings. The shower, within the numerous roles that color appliquides; hybridgings and applications and the colors and as the colors and as the numerous roles. Inglighters, However, within the numerous roles that color complay in terms of herencity, one practical characteristic should not be overlooked, and that is the tonal value. Chose again, it an ortherwise the hund turket to be selected coproprinter instructions in synocales to be selected indicator of promovies and priority. If color laters, burchon consectly when value of programs, they well certainly be equally strong in color.

As with all principles of design, those presented here serve merely as general rules and guidelines; there are no definitive dos and don'ts. The following pages in this section look at examples and exercises that demonstrate some of the intricacies, fine balances, and anomalies that designers face when creating visual hierarchies.

IN CONSIDERING THE HOLE OF TYPE AS A REGULATOR AND CONTROLLER OF HIERARCHIES, IT IS NECESSARY TO KEEP IN MIND THAT LETTERFORMS MAKE WARDE

ographic hierarchies are preforminantly governive vy disensible of lessive and less. Letterforms, wurdt, and leve syng characteristics of patterning, depending spon the siness of low generated, logether with the scale and solare minuth, a viewer is distinction to a prefer or heser degree, sites al typeface, point size, list, weight, tracking, line Chokes of TypeReck, park 196; titt, weight: (TARNE), in packing, and general spatial (disht)sites: affects the desi-te type, and consequently, create attinuing dagrees of and dank. Similarly, these catalogishting characterization poor the kind of patient that is made. However, when composing differing varieties of closes and lose, design abuald be programed to made visual polyments and lose, design abuald be programed to made visual polyments. Logistat

IN CONSIDERING TH ROLE OF THE AN CONTROLLET HERCHES, T NECESSARY IN CONTROLLET HERCHES, T NECESSARY IN CONTROL HAVE MEANING

EXTRACTION EXTRACTION MILL STELL MILL STELL MILL STELL DOTTONCE

Les dispanse deuts the places content. Les dispanse deuts the places are separated and content the environment. There were the places of the advection of the section of the environment. There have the places to be deviced, but if the scale work that are and any three there have have to be deviced, but if the scale work that are and any three there is a strack to be deviced, but if the scale work that are and any three the places are also be associated and the scale of the scale of the scale of the places are also be associated and the scale of the scale o

The general constraints of the second of the second of the second of the second of second on second of the second or out and head (private). A for second that facture associated with spectra or compared to the second or the constraints of second or second or the second or the second or the constraints of second or the second or the second or the constraints of second or the second or the second or the constraints of second or the second or the second or the constraints of second or the second or the second or the constraints of second or the second or the second or the constraints of second or the second or the second or the constraints of second or the second or the second or the constraints of the second or the second

where, to change of our instance constraints instances on another modelier. To the ordering all data times we and vieways we entrograde the constraints modelier. To the ordering all data times we and vieways we entrograde to the constraints and the time of the constraints and vieways we entrograde the constraints and the time of the constraints and the constraints are the time of the detection and the time of the constraints and the detection and the constraints, and all the time the marks, one gains can constraints that and the constraints, and we there we are can all of the constraints the balance to be detected accounted, and there is the time time.

product of damp of the second second

65 EXERCISE FOUR cent est manue ten l'en require public la serie pui a qui qui da menzi. serie pui qui qui qui da menzi. serie subtet est cent hait per serie subtetti a prevanta est can re qui de l'entre est serie est est est cent est de remement. Serie est emplete anime est est est begi altra estance anime est est serie est est est est est est serie est est est serie est est est serie est

AND WE'LL NEVER STOP UNTIL THE SWITCH. THERE IS NO INHERITED SHUT OFF SWITCH. THERE IS NO INHERITED SHUT OFF SWITCH. THERE IS NO WILL AND ANOTHER PARTS INHERITED ING TELLIN MONED ANOTHER PARTS INHERITED

Another modern is overprenative secondartion and built and canning secondaria. It is the provide secondaria secondaria secondaria secondaria secondaria secondaria secondaria secondaria in termo secondaria secondaria secondaria secondaria secondaria secondaria secondaria secondaria secondaria in termo secondaria secondaria.

> I de cere tenan en en en en en en y tenante la cere tenan en persona en genan la mais a la tenan en encelera en al en tenan la mais a la cere en encelera en al en tenan la cere en en en en encelera en en encelera barran persona en encelera en encelera tenan en encelera en encelera en encelera la cere encelera en encelera en encelera la cere encelera encelera en encelera la cere encelera encelera encelera encelera encelera encelera encelera la cere encelera en

NHER

which is it are why we taked here on the plant versories in this task there are given a sequence and and and the sex given are associated and the sex given are associated and the sex given are associated and the sequence and and the

WHY OH WHY MUST EVENING LIL-YOU GET NOTHING OUT OF LIVING LIL-YOU GET NOTHING OUT OF LIVING LIL-NUSE EVERYBODY. NEEDS TO HIDE LIWHY NUST EVERYONE BE IN DISGUISE ENDTHING OUT OF LIVING LIES ENDTHING OUT OF LIVING LIES ENDTHING OUT OF LIVING LIES

> to lot of really took 14 too namooles the low real boots of a source of the low real low real boots boots and low real of the low real low real boots and low real boots and low real low real boots and low real boots and low real low real boots and low real boots and low real low real boots and low real boots and low real low real boots and low real boots and low real low real boots and low real boots and low real low real boots and low real boots and low real low real boots and low real boots and low real boots to boots and low real boots and low real boots and low real low real boots and low real boots and low real boots to boots and low real boots and low real boots and low real low real boots and low real boots

The data and an other while the data in anticent of the data and the set of the data and the dat

344 DESIGN, LLC WHAT YOU THOUGHT YOU HEARD CD PACKAGE, BORIALIS A limited color palette and an almost entirely

typographic layout typify Stefan G. Bucher's design for the CD cover of Borialis' *What You Thought You Heard*. Headings and sections of text are given prominence through bold, all cap, sans-serif letterforms, with many anchored to the bottom of the page, or running into the abstract, colored shapes that are used as illustration. Quantities of type make clever use of indented and exdented copy that repeatedly attracts the reader to where the layout changes, and encourages their continued attention through to the end.

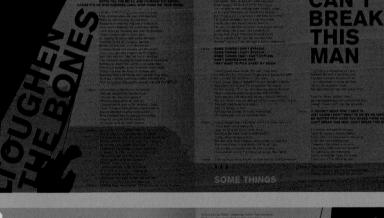

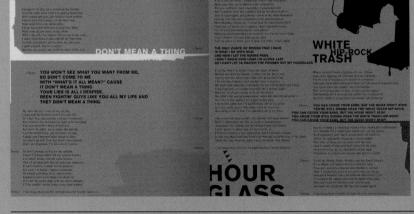

 CLIENT
 DESIGN
 TYPOGRAPHY

 CAPITOL RECORDS
 STEFAN G. BUCHER
 STEFAN G. BUCHER

ART DIRECTION MARY FAGOT STEFAN G. BUCHER CLIENT BATTERY PARK CITY PARKS

CONSERVANCY

DESIGN L. RICHARD POULIN DOUGLAS MORRIS

PHOTOGRAPHY

VARIOUS

TYPOGRAPHY L. RICHARD POULIN DOUGLAS MORRIS

COPYWRITING BATTERY PARK CITY PARKS CONSERVANCY

POULIN + MORRIS INC.

BATTERY PARK CITY PARKS CONSERVANCY 2001 PROGRAM CALENDAR

Lilac, lime-green, and orange form an unexpected color palette for this City Parks Conservancy

Calendar by Poulin + Morris. The recipient is drawn primarily to the almost electric contrast between lilac and orange, then on to the decorative display face that is used for section headings. Most smaller text-in black, and layered on top of colored backgrounds-is seen later.

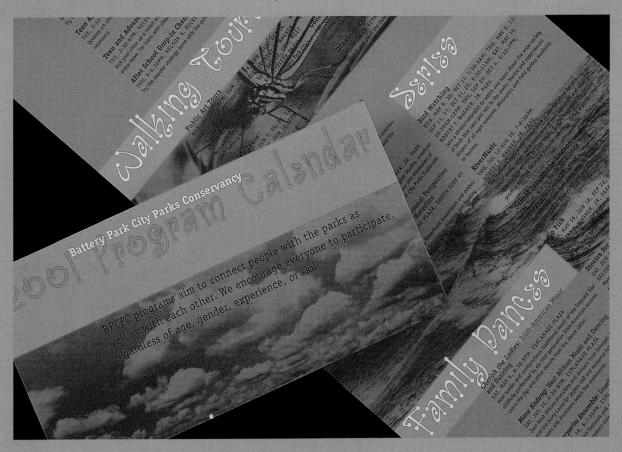

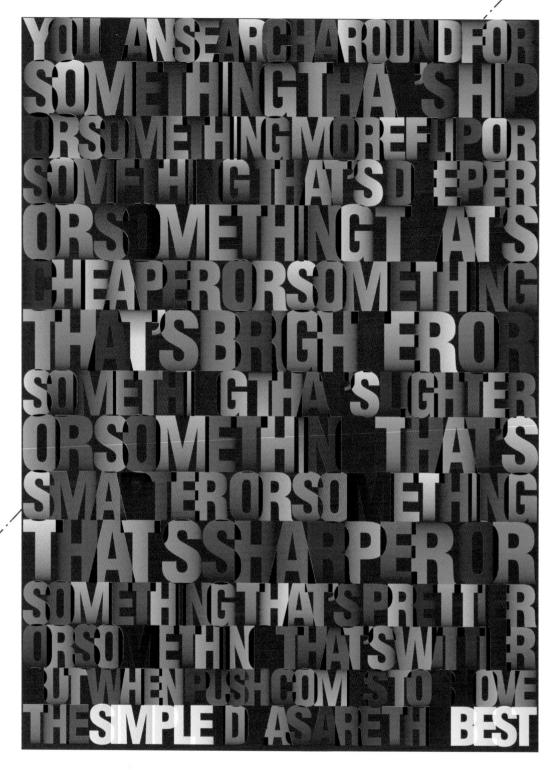

CLIENT JOHNSON BANKS DESIGN MICHAEL JOHNSON

TYPOGRAPHY MICHAEL JOHNSON

ART DIRECTION MICHAEL JOHNSON

JOHNSON BANKS SIMPLE POSTER

Conveying the message that simple is best was Michael Johnson's aim with this complex design. Statements built up

through graduated, overlapping, colored letters of varying size form the substance of this poster. Even after trying at some length to read the complex message, the reader cannot help but be drawn to the white, "simple" and "best" along the bottom line.

ORDER OF SERVICE

Canon (Pachelbel)

WELCOME The Reverend Carry Thompso

INNE Instant, enable, God pay deline, mark neurolan, God pay deline, mark neurolan, Barros and Markon, et Danis, Instante, Annoue Markon, et Danis, Instante, Annoue Markon, et Danis, Markon, et Markon, et Markon, et Markon, Marko

> READING 1 Corinthians 13 1-1 Read by Carolyn Knig

THE ADDRESS

SIGNING OF THE RECISTER

BRIGHT PINK BECKS AND JAMES' WEDDING STATIONERY

Mike Illinghert

Sally Illigherth

The typographic design for this wedding stationery involves a number of layers of information. The first text to be seen

announces that "Becks and James are getting married" (on the place names, "are married"). Secondly, the reader focuses on three tiny red hearts just above the black band which connect visually with four red letters within the allover typographic texture, creating the word "love." The reader is then left to go through the background texture and take in the various wedding-related messages. Inside, "love" is formed in huge letters that, despite being very pale and running behind the order of service details, appear surprisingly dominant because they are familiar and have already been established as significant within the design.

REBECCA

 CLIENT
 DESIGN

 REBECCA NEWTON
 CAROLYN KNIGHT

TYPOGRAPHY CAROLYN KNIGHT

AND RECORDS JAMES KI

ART DIRECTION

Holler's unusual design for Island Records makes dynamic use of space and

sale. "Span" changes position within the screen, but is ways the most noticeable single element within the design ecause of its large scale, weight, and density of fone. Even then the letterforms drift partially out of sight they remain at as significant, the viewer remembers and knows what sy represent. The navigation system, seen second, is also cominently displayed, using smaller, bold, black type that hanges scale and color with mouse overs.

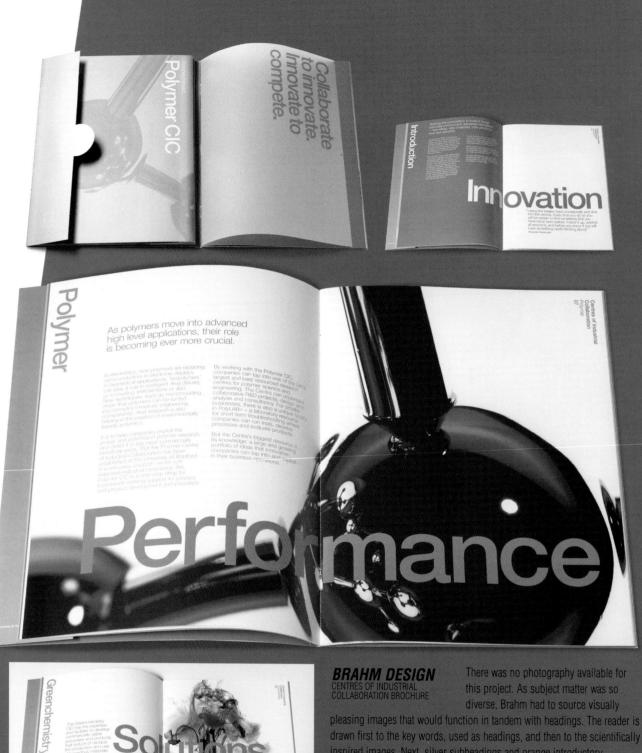

pleasing images that would function in tandem with headings. The reader is drawn first to the key words, used as headings, and then to the scientifically inspired images. Next, silver subheadings and orange introductory statements attract attention, leaving lightweight silver text as the last element to be accessed.

CLIENT YORKSHIRE FORWARD

DESIGN LEE BRADLEY MARK STARBUCK

TYPOGRAPHY MARK STARBUCK

ART DIRECTION LEE BRADLEY

VICes

Searc

eria

Canhest of hote Collaboration Muoratis Anti-Autoratis Anti-Alesearch has produced astonishing in recent years with new products sses creating exciting opportunities g-thinking businesses.

Jineering ICe

ise

Breakthrough

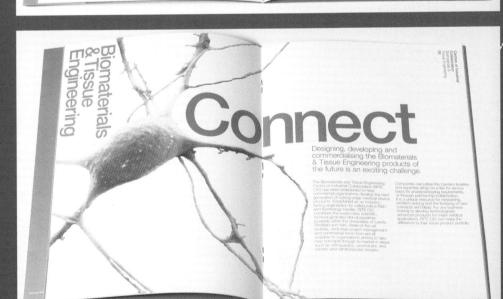

73 TYPE DRIVEN

and the second

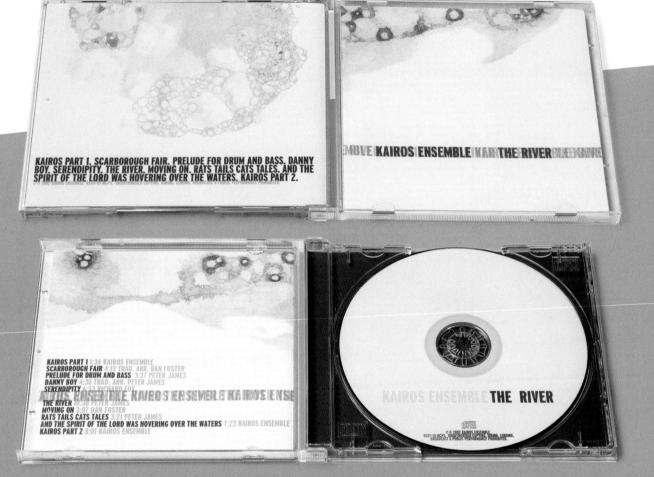

CLIENT KAIROS ENSEMBLE

DESIGN GARY MACILWAINE

TYPOGRAPHY GARY MACILWAINE

ILLUSTRATION

RACHEL

COLLINSON

SPARKS PARTNERSHIP THE RIVER CD PACKAGING A prominent, dense line of layered type runs through this design for Kairos

Ensemble, and as a result of the density of color and tone it is definitely the first element to be seen. "The idea was to communicate the motion and effect of water, while retaining readability and correct reading order," says Rachel Collinson of Sparks Partnership. "The text has been layered to create a kind of flow, and color is used to pull out the title from the main 'river'," she continues.

ART DIRECTION GARY MACILWAINE

House Y is a measurement of the second of the second

Leaf or blade, or sheath; telling of the hidden.

CS fort21 underneath, seek in other provides the set on other provides it without back, set of the set on one back provides it on one back provides the set one of the set of the set of the set of the set of the set of the set of the the set of the set of the set of the set of the the set of the set of the set of the set of the the set of the the set of the the set of the set

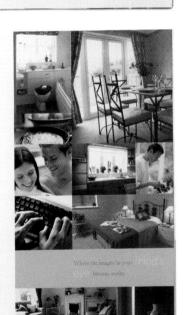

CLIENT WIMPEY EAST MIDLANDS **DESIGN** JESSICA GLASER CAROLYN KNIGHT TYPOGRAPHY JESSICA GLASER CAROLYN KNIGHT

COPYWRITING CAROLYN KNIGHT ART DIRECTION JESSICA GLASER CAROLYN KNIGHT

BRIGHT PINK THE ORCHARDS, BROCHURE

Within the pages of this brochure for

Wimpey housebuilders, a distinct patchwork of many deep-colored images exists, but it is the typographic patchwork that we will focus on and discuss within this section.

A mix of type sizes, weights, and colors have been brought together, creating a palete of typographic treatments that not only complement each other, but also set up recognizable styles for different levels of information. Density of tone—controlled by type size, leading, intercharacter space, and color plays a large role in directing the order in which this information is accessed. Readers are likely to be drawn to the largest type first—the lowercase words form verses of Christina Rossetti's poetry. Smaller, black text is then accessed, with bold, blue, all cap, widely leaded copy being seen next.

POULIN + MORRIS INC. SUSPICION BOOK JACKET

Large, bright white typography, extending vertically down the cover, is $\mathbf{\Gamma}$

ANovel

seen first on this jacket for *Suspicion*, designed by Poulin + Morris. This prioritizing is a direct result of the titling and author detail contrasting dramatically with the red-and-black halftone photography that completes this cover design. The red, as well as being bright, has a fairly dark tone which throws out the white type particularly strikingly.

CLIENT DESIGN NORTON L. RICHARD POULIN

TYPOGRAPHY PHOT L. RICHARD POULIN ANN S GRAPI

PHOTOGRAPHY ANN SPINDLER GRAPHIS PHOTO

Robert McCrum

A Novel

Suspi

WARNER MUSIC WILL PYNE

TYPOGRAPHY WILL PYNE

CLIENT

ART DIRECTION WILL PYNE

DESIGN

HOLLER FUNERAL FOR A FRIEND WEB SITE

This Web site opens with the band's name.

Funeral for a Friend, dramatically interpreted in white "haloed" type on a black background, using a typeface reminiscent of those on sympathy cards. The impact is so powerful, and the appearance so distinctive that, despite the introduction of full-color imagery on subsequent pages, the viewer is persistently drawn to and through the white-on-black text, whether this be heading, subheading, or body copy.

CLIENT SLM

DESIGN

MIRCO ILIC

PHOTOGRAPHY

ART DIRECTION MIRCO ILIC

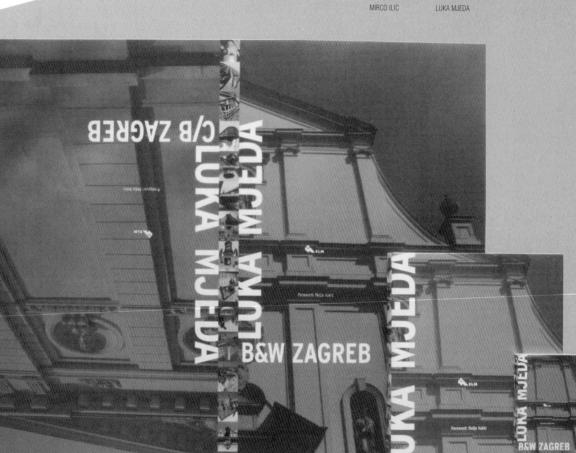

MIRKO ILIC CORP. B&W ZAGREB

Strong, white, sans-serif, all cap letters are the most noticeable elements in this design, both when it is folded to form a dust jacket for Luka Mjeda's book, and when it is opened out to create a poster. This is particularly

GREB

because of their scale, clarity, and contrast with the monochrome sections of buildings behind them, but also because, strikingly, they bleed off two edges of the front cover of the book, and run vertically as well as horizontally in the poster, with some words actually upside down.

	The second s
CLIENT	DESIGN
SELF-	MATEEN KHAN
PROMOTIONAL	
PROJECT	

TYPOGRAPHY MATEEN KHAN

ILLUSTRATION PHOTOGRAPHY MATEEN KHAN MATEEN KHAN

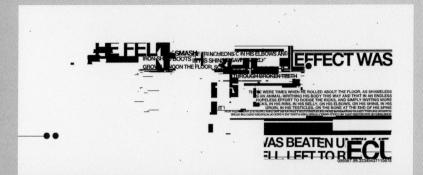

MATEEN KHAN DESIGN

1984, MULTIMEDIA PIECE

The designer's intention in this multimedia

piece is to create an interactive environment that reflects his personal interpretation of George Orwell's novel *1984.* Haunting words and phrases attract the viewer initially, as they are the clearest elements within each page, and because they stir chilling emotions. It is human nature to have a fascination with the macabre, and the viewer readily allows the words to set the scene. Cut-up type, dark gritty images, and carefully selected colors then build up the atmosphere, with smaller text, and less legible type drip feeding further sinister narrative.

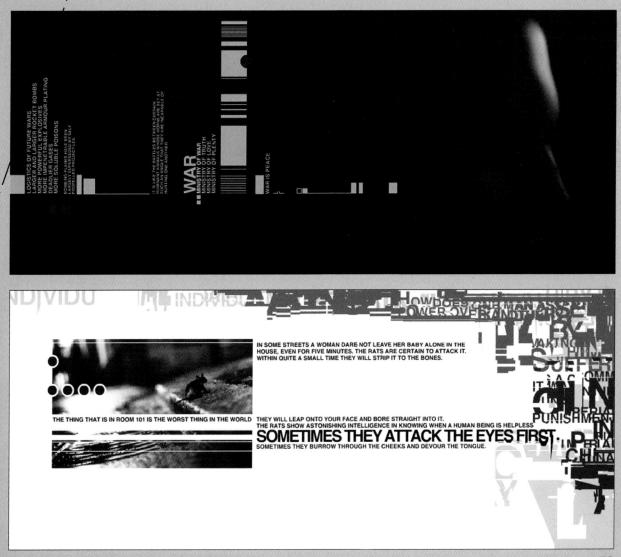

ALLETICAL PIECTOGRAPHY has been a constant source of responsive for editors, at disorders, and pronegatives, about the separating general of editorial and advecting a pictography. Not men's a catalog of great images, from the previous year, the book others a commentary -develop leady to advactables and committies, before holders

eminds us that context and image size play a major role how we perceive a photograph.

on the address for search two decades has clean to the low data participation provides the low York Tarves Magazine Profoundaries of nation can the low York Tarves Restrict Horizongha in a low reliance of the Corporations are formemory in photographs of all incide. However, They often use magas in ways that disregard contents and the makers interface underwind per limit that has hearenedly defined decamentary proprography. We made the validable.

In bit which a limit of previous protocopatity, super reality in a grain limit, and in each parts calculated on the careful off to fully allow and a limit on the careful deviced data and the second a limit on the careful data and allow of the fully wave of the produced to the spreader. The the entropy of the second by location that produced to the entropy of the second by location that produced to the entropy of the second by location that produced to the entropy of the second by location that produced to the entropy of the second by location that produced to the entropy of the second by location that produced to the entropy of the second by location the second of these factors to the second by location of book, Beauty Network, entropy as it who to the QCT enters? The strugges of Echand Statistics and Affred Screenitz - and tables Network Affected Action to convince people to view photography at an art are, by new ancient history. With art achools floureshay and many young image makers deliving into the history of them indume, we are more and increas photographic that quoties the three and the formal approaches of past masters in true costimutes hashin.

Recentrations, ITS is policities age for smart photographers who do of limit themselves to a single practice. Facilian photographers to Ito war zones, relativity and the photographer that are litter of Duced as books or exhibitions, which sometimes become reduced as books or exhibitions.

Readers and page-turners ask: "Dot this really happen, or was it so billiontly produced that it appears real". Better read the orditi. "Documentary photographens ask: "Is this supposed to be faunty or ironic? Is this the fouriam of immery!" Am I is on the gate#0.77 each to mixed to my atheat stance that I cont entities a difference assistance.

Magazame rather than the line barries where where is a nucl and what is efforts. Hen range that a bolgs fabbrar, which mores soundness that is not exclusional view, on both values. But balar, advertising and the sound of the sound of the sound of the sound of the sound where its hom, pages photographic years upon expected in the intervent of the most provided in solid balar. All sound is the values of the most provided in solid balar, the thermal more than the sound balar provided in the bond message is solid or the most provided in a solid balar, the bond while the company. Thereas the intervent of balance's before a company. Thereas the next provided in the page by them and company. Thereas there and balance's constant work to the solid the Halance's most in the page of the head of the Halance's most in the page and the head of the Halance's most in the page and the head of the Halance's most in the page and the head of the Halance's most in the page and the head of the Halance's most in the solid balance and the head of the Halance's most in the solid balance and the head of thead o At the same time, some photopownalists are going to a socker more styllized approach so that they too can inter an advertising world that currently embraces the documentary style. But many still ask, "How did people term to make money from my socially concerned strikes where i've competing for a day rate and much higher this where size more Sorth and service?

I book for tuttit and vencional impact is imagine. That's mp passes having traveled the richt terrain of imagines for many space. Yet' can still be sedueed and willingly menipulated be plottieverweige as first an extensional yet someone patieng as the subject revieweige as first an extensional yet will also a kit long as the subject is not comparisoned, it makes me first connected and i am apatief to their.

This years look is a perfect in the flue further and year bulknow. It is exactly where war is locate and the flue of it for me are its each year and the perfect war and the term of the log henging. "Constraints are in the analysis are and log henging." Constraints are in the analysis are and the log henging. "Constraints are log henging and of the terms, hendress Area Webs Exerc protocoparity constraints of the Maximum of the Area Webs Exerc protocoparity in because the adjust and an analysis area of the marks do the mark based on the constraint protocoparity and performance the adjust and any with behavior documentary photographic because the adjust and any with behavior documentary photographics and because of the constraint protocoparity of the marks do the mark the based on the constraint protocoparity of the marks do the test them of marks.

> WHAT STEICHEN WOULD HAVE DON WITH PHOTOSHOP

DESIGN STEFAN G. BUCHER

344 DESIGN, LLC AMERICAN PHOTOGRAPHY 17, BOOK DESIGN

SEDUCED ENLIGHTENE

"Seduced and Enlightened" is the title of the opening spread in Stefan G. Bucher's design for *American Photography 17*.

This design proves that titles do not have to sit at the top of the page to be read first; neither do they have to be shown in the darkest, or deepest color. Surprisingly, on these pages, the reader is drawn first to the large, white, sans-serif, all cap heading, which is reversed through a light, flesh-colored background. They are then guided on to view the lighter texture and tone of copy printed in black. CLIENT MARK HEFLIN/AMILUS INC.

TYPOGRAPHY ART DIRECTION STEFAN G. BUCHER STEFAN G. BUCHER

80 EFFECTIVE VISUAL COMMUNICATION

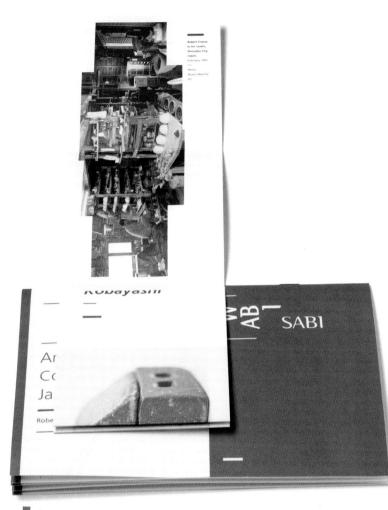

FISHTEN WABI SABI CATALOG

This unusual format was devised by

Fishten for the catalog of an exhibition concerning contemporary Japanese ceramics. Entitled Wabi Sabi, the catalog visually sets the scene for this hybrid North American/Japanese exhibition. All imagery is restricted to the small, outer, wraparound sections, with the rest of the catalog devoted to text and a thoughtful typographic interpretation of contemporary Japanese arts culture. Typographic treatments ensure that the type is striking. These include large paragraph indents, line breaks in the middle of words, and paragraph orientations at 90° to each other, all situated in generous space. Printed in single color, each page uses a weighty pink bar that acts as an anchor, drawing both text and the reader's attention toward the bottom of each spread.

81 TYPE DRIVEN

IMAGE DRIVEN

This section examines how imagery controls hierarchy in a layout.

Just as the previous section does not deal exclusively with type, so the content in this part does not talk about the use of imagery alone. Unless a design excludes type altogether, text will contribute to the hierarchical structure, as all elements within a layout are viewed in relation to each other.

The most significant aspect of sequencing visual perceptions through imagery is the subject matter of the images. It is interesting to recognize the magnetic power of the human (and to some degree animal) form. In many of our day-today communication processes we look at whoever is speaking to us, and body language, especially facial expressions and hand gestures, are integral to our comprehension. Consequently, the inclusion of a picture showing a person, or in fact any part of the human body, provokes an involuntary focus of attention. Faces, eyes, mouths, and hands all draw the viewer's attention.

Visual themes that stir emotions and aspirations are particularly inclined to attract attention. Violent, sentimental, or shocking topics tend to be more alluring, and images of kittens or babies, famine or war, are always likely to secure visual priority. It is also natural to dream of improving, changing, or updating ourselves, our homes, and our lives, and images that depict such desires can be amazingly seductive, regardless of the visual treatment.

The cropping of imagery has a fascinating impact upon ordering the content of a layout. Newspapers very often use the same photograph of an event, but crop it differently. The tabloids often seek immediate attention, with images that exclude the wider environment and focus on the emotional closeness of a moment. Broadsheets tend to allow the viewer more time to take in the whole picture, and maybe create a sensitive headline that is perceived first, to set the scene. Cropping can also create very unusual and unexpected image content that draws attention because the reader is curious or mystified. Synergic meaning can be particularly intense and inviting, as when a number of images are cropped and juxtapositioned in a surprising manner. Many of the same principles that affect typographic hierarchies are pertinent to the visual sequencing of imagery. Darker tonal values and dynamic textural patterning will dominate within a layout whether created by type or image, and spatial distribution, together with changes of scale, can be used in just the same way to draw the reader's eye. Pictures, however, constitute a universal language that is accessible to all, for the most part transcending nationality and, to some degree, age.

Pictures can also convey a huge amount of information far more speedily than the numerous words that would be needed in their place. Therefore, as it is human nature to assimilate the most easily accessed information first, the dominant feature is likely to be imagery. If imagery is to be read after type, all aspects of tone, texture, color, scale, composition, and, of course, content must be carefully balanced in order to reduce its level of prominence.

Graphic elements, such as geometric shapes, background tints, and patterns, all come under the image banner, and play various roles in the hierarchical chain. Daniel Bastian from Form Fuenf Bremen, has produced a brochure for Scharf.Rechtsanwälte that uses dots as attention grabbers and persistent visual markers to lead the reader through the pages. Even when the dots become fainter they rank high in the order of perception, as the reader is geared to seeing them as an informational system.

Background tints and patterns are rarely overtly acknowledged as being viewed first, but intriguingly, they have the ability to set the scene, and can give a masculine, feminine, or cultural bias to a design; a floral texture will be perceived as feminine, checkerboard squares are more likely to be viewed as masculine, and batik will immediately add cultural connotations. In Lauren Schulz's design for *Surface* magazine, cultural patterns play an important role. A contemporary take on traditional Japanese prints makes the article's subject immediately clear to viewers. Whether consciously or unconsciously, readers will absorb this information before taking in other elements in more detail, and it will influence their perception and interpretation of everything else.

The metonymic and metaphorical use of imagery can add to its power. In many respects, it is the simplicity and immediacy of visual elements that enable them to be seen and understood comparatively instantly. Metonymy uses one person or object to represent a far greater whole. Visual metaphor points out resemblance by using substitution in a very poignant manner; for example, if a national identity in the form of a flag becomes the design featured upon a doormat, the intended perception of that country is very clear.

The following pages examine exercises and examples of work that involve some of the design decisions to be made in order to create different levels of hierarchy with image. As with the designs featured in the first section, they serve merely as models that demonstrate some of the numerous approaches available within both print and screen contexts.

CLIENT SURFACE MAGAZINE DESIGN

LAUREN SCHULZ

COPYWRITING KATIE JACQUARDE

Chairman

The year 2001-2002 has been a princip of abblastion and stanky yours. The initratence of the last few years calministing in the complete relabilithment of the Cypp and the complete relabilithment of the Cypp of the complete relation to the major of the complete of our work – Family Centre, Majit Centre, Modelfa are dinarithment of the commonline of the complete relation and the new instaktive fiture common diseasity and another the new instaktive fiture of the complete complete mathematical another to work in pathematical authority and another and another in work in pathematical another the packders in the our and also with the local authority.

static, and we are now considering the steps necessary to bring about further progress into 21st century methods of providing for the needs of the homeless. More will be said of this in the future. During the year we accepted with regret the

textstems as incased of adorge harry water, for many bencher "Wom with the accessed tablety a "back" padance over many years and wich him God, and padance over many years and wich him God, and benong in his (canfo), retormet. Heter this opportunity to mank the staff, Management Committee and Tutates for their hard work over the last year. We rary that God's blessing with continue to rare of the Charsy's work and that we shall

remain open to His voice as to the direction for the future. Latso wish to thank all those who support us in the work, prayer partners, donors, and ot occurse the volunteers who faithfully come day after day to help in this vital work.

Wilfred L Wyatt Chairman of Trustee

TYPOGRAPHY

PHOTOGRAPHY

JOHN ANGERSON

LEE BRADLEY

CLIENT ST GEORGE'S CRYPT DESIGN LEE BRADLEY MARK HOWE MARK STARBUCK

ART DIRECTION LEE BRADLEY **BRAHM DESIGN** REALITY, ANNUAL REPORT & ENTERTAINING ANGELS BOOK DESIGN

Shown on these pages are Brahm Design's solutions to an annual report, and a book about St George's Crypt. Both pieces make

dramatic use of impactive black-and-white photography, which is always seen first. "The documents have simple typography and layout that complement the powerful photography. Most spreads have a main heading, text content, and image," says Lee Bradley, Brahm Design team head.

Entertaining Angels is designed in such a way that readers can access information from any page, without the need to read the entire book from start to finish. Images that are dramatically cropped dominate the pages; all are carefully placed to create the most impact.

Homelessenses is an ope of problem. For hope who have nowhere is opp the statuth in a role statu in the 21st contraytran it was in the 1938. For most of sociatly is a something which regress is something which in the statut label back. Their regress is something the statut in the statut label back the finite something and the statut in the statut label back interesting. Argets label the somet of hundreds of globale backets with each other and his sets (which invest tracy) the encounter with each other and his sets (which invest tracy) the encounter with each other and his sets (which invest tracy) the encounter to some process lefters. The memories are encounter of times pask backs of status of backets and hangeming in the dyd (udd) backs, from an 81 yang of weather

presente un clean clouries, to the man who collected on helpapeers from bins and then hundled them coll tike a page definery boy for okryone to read. These are also the stories of the man and women who drink thomselves into oblivion, of those whose shoes if is to badly that their the rules grow underweath them feet, and of the scores of holpers from

a life better Collectively their memories and the photographs which go with them capture the history of the Crypt over more than 70 years. We are proud to have been involved in this project.

DESIGN

LEE BRADLEY

Clare Monrow, Controller of Programmes, Yorketrine Nativesine

St George's Crynt Entertain ng Angels Editor an Clayton

CLIENT ST GEORGE'S CRYPT TYPOGRAPHY LEE BRADLEY

 COPYWRITING
 ART DIRECTION
 PHOTOGRAPHY

 IAN CLAYTON
 LEE BRADLEY
 JOHN ANGERSON

CLIENT	DESIGN	TYPOGRAPHY	
THE WIRE	KJELL EKHORN	KJELL EKHORN	
MAGAZINE	JON FORSS	JON FORSS	
	ART DIRECTION	DUOTOODADUW	

KJELL EKHORN

JON FORSS

JAKE WALTERS

ION-FORMAT DRIATIC BLUES, MAGAZINE SPREAD instantly catches the The dominant portrait reader's attention in this

ticle for The Wire magazine. It is not only the scale or opping of the image that causes this photograph to be so arresting, but the fact that Christian Fennesz is looking directly into the eye of the viewer. Decorative, lightweight, outline letters are the next element to be seen, and these make up an unexpected heading for the article.

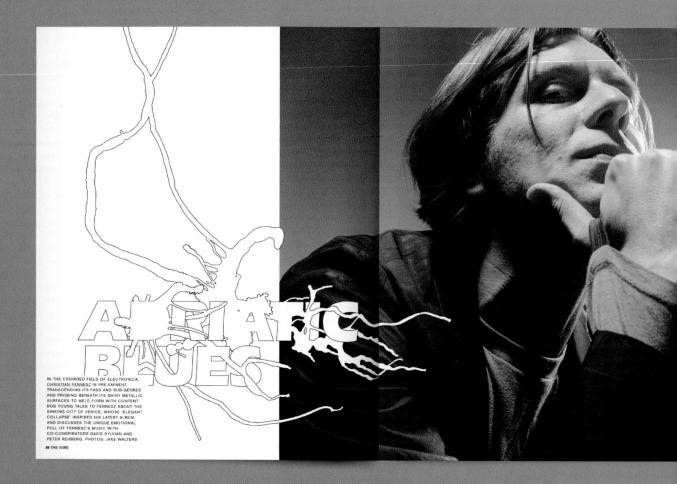

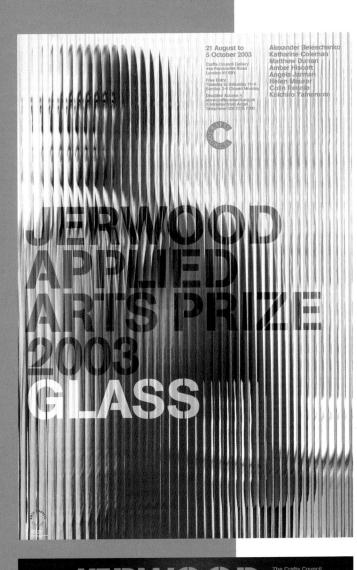

A

R

G

 \mathbb{C}

ERWOOD 55 COUNTION

CLIENT CRAFTS COUNCIL

DESIGN

NCIL IAN F

IAN PIERCE

ART DIRECTION ALAN DYE BEN STOTT NICK FINNEY PHOTOGRAPHY MARTIN MORRELL

NB: STUDIO JERWOOD APPLIED ARTS PRIZE 2003: GLASS NB: Studio have created an abstract effect by using fluted glass for this image-

driven piece designed to publicize the Jerwood Applied Arts Prize, which was awarded for glass in 2003. The viewer is instantly intrigued by the obscured view offered by this decorative glass. Ian Pierce has used enlarged sections of the image to create equally captivating cover and postcard imagery. Headings and titles are seen after the image, despite being created with a bold, stencil-effect, sans-serif typeface. Supporting copy is seen last, but is integrated through use of turquoise tones drawn from the color palette of abstract imagery.

Within the pages of this PriceWaterHouseCoopers image brochure, the viewer is drawn into spread after

spread of full-color image. Each shot bleeds off four edges and all type is overlaid. Because of the scale and quality of the photography, viewers will seek to look through the panels of white copy, deep into the scenes of the company's life.

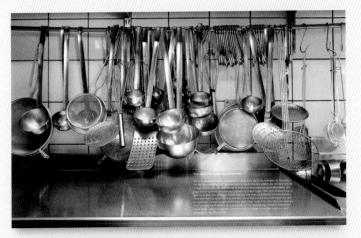

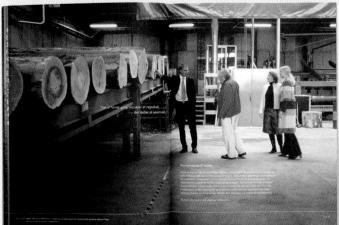

CLIENT	DESIGN
PRICEWATERHOUSE	JESPER VON
-COOPERS	WIEDING
	MUGGIE RAMADANI

COPYWRITING SIGNE DUUS

ART DIRECTION JESPER VON WIEDING PHOTOGRAPHY SIMON LADEFOGED

MUGGIE RAMADANI

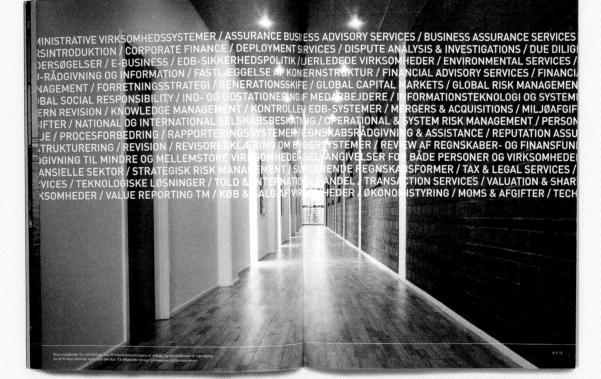

Dark, moody images extend across the spreads of *Surface* magazine's "Things Got Stormy," with each right-hand page containing a broad white panel that

accommodates and separates caption detailing. However, there is no doubt that viewers will be drawn to Blinkk's atmospheric photography first because of its dark tones and consequent visual power. In addition, the titling for this fashion editorial, although large in size, is hairline in weight, and this allows the focus to be on the image behind it.

JOHNSON BANKS V&A SUMMER POSTER

johnson banks' promotional poster for the permanent collection of the V&A simply features an evocative black-and-white

photograph from the museum's classical sculpture collection. This shot commands attention, drawing the reader through the cleverly crafted heading to focus on the smooth lines of the figure.

CLIENT		
VICTOR	IA AND	
ALBERT	MUSEUM	
(V&A)	1	

DESIGN

TYPOGRAPHY MICHAEL JOHNSON MICHAEL JOHNSON LUKE GIFFORD LUKE GIFFORD

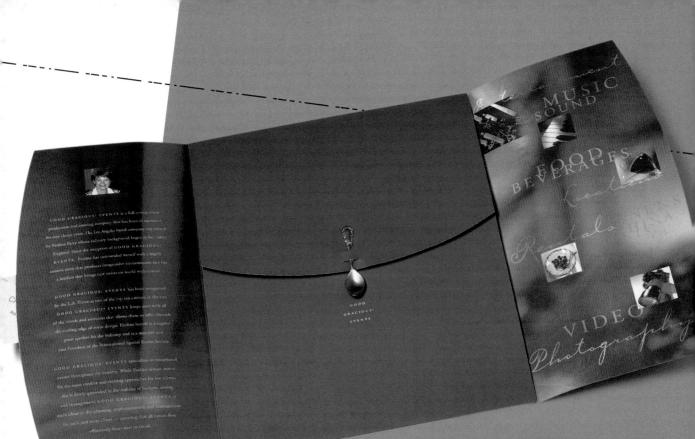

IE DESIGN + COMMUNICATIONS GOOD GRACIOUS! EVENTS FOLDER Using a luxurious shade of purple, this folder for Good Gracious! Events saves its

most striking and surprising feature until almost last. The center section is held closed with a small gold spoonand who could resist sampling the tactile qualities of this unexpected 3-D item? Due to its physical location, this miniature spoon also acts as a pointer, drawing the reader to the company name, which is reversed through the deepcolored background.

> CLIENT GOOD GRACIOUS! EVENTS

DESIGN MARCIE CARSON

Introducing one of the most respected names in international textiles. A company that adds value to your business by producing high quality products. Welcome to the world of Bulmer & Lumb.

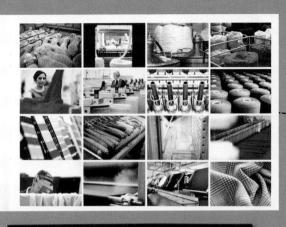

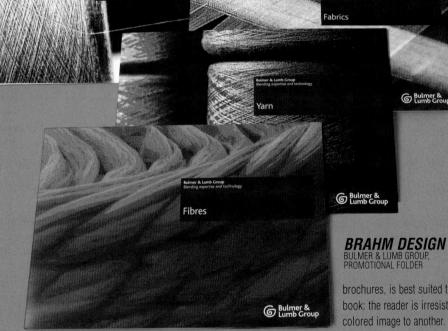

Company overview

CLIENT	DESIGN	TYPOGRAPHY
BULMER & LUMB	LEE BRADLEY	LEE BRADLEY
GROUP	ZOE TYLER	ZOE TYLER
Copywriting	ART DIRECTION	PHOTOGRAPHY
Bill Lyne	LEE BRADLEY	JOHN HUTCHINSON

There is no doubt that this folder, containing a number of landscape-format

brochures, is best suited to the image-driven section of this book: the reader is irresistably drawn from one brightly colored image to another. "The first spread uses images to reflect the journey through the textiles business, starting off with ingredients such as wool and finishing with the end product-cloth," says Lee Bradley of Brahm Design. "Color needs to come across strongly," he continues, "as dyeing is a core activity for Bulmer & Lumb." Dynamic contrasts of scale within the imagery contribute to the vitality of the spreads, and also affect the hierarchical status.

G Bulmer &

CLIENT	DESIGN	TYPOGRAPHY	COPYWRITING	ILLUSTRATION	
RECHORD	RACHEL	IDENTIKAL	STEFAN	RACHEL	
	COLLINSON		CARTWRIGHT	COLLINSON	

RECHORD RECHORD WEB SITE INTERFACE

Hierarchies within the pages of Web sites may not be finite as elements are

likely to change with, for example, mouse overs, as well as through animation. Rachel Collinson, of rechord, has chosen to add to this "infinity" by offering the viewer some control over the dominance of areas, giving them the opportunity to change colors with the mood-mixer buttons, and even to turn off the eight squares that constitute the interface if they appear too powerful. As a consequence, the visual dynamic moves from one area to another, and can be governed by the open door, the interface, or the interactive zone on the left. These screenshots show some of the alternatives available, and demonstrate the changes in emphasis.

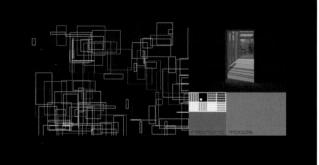

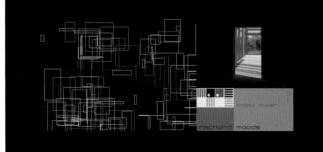

Observant Observatory tsle Observation The Observatory* The Obsente Helmin-ME OF REBIRTH -444- 1444- 1444- 1444- 1444- 1444- 1444- 1444- 1444- 1444- 1444the mistates and the chances we and put them all in a baskot 150 65-12 56-52 07-56 15-52 15 Srt Srt the official HAN HILL HAN HAN HAN HAN HAN HAN HAN HAN from of Fall Ask 649 Alt. When the Litt This Sed Sing Take to Old Pullimetry Generic did Anthen being the diff that the fore whe the fore admit & day bn : 015-19() ve will admit too (swellow to words us openal) ann we will learn to admit defeat Time Understands Wit wants to Tinc of rebirth Loved ones be loved * Learn, we Belonging All those who gather Don't be alarmod Don't be afraid We'll tell them ***** 11-14 ****** ****** 14:14 01:14 14:14 14:14 14:14 14:14 All in the human cace Tonal values Coh we do **14** What we do **14** A little kindness too, So that others gan do what we do they want to KINETIC TIME OF REBIRTH CD PACKAGING generally play HILL HILL HILL of Rebits a strong part in To All those who sook governing the hierarchy of a composition-the Happiness, keep a record of all your sadness darker the tone, the more it attracts attention. However, on the pages of the booklet that comes with this CD, it is interesting to note that certain experiential recollections influence the order of reading and override the tonal principles. Handdrawn, handwritten elements make a more direct In and personal connection, and crossed-out text, 1000 0 together with torn-out pages, dominate by 12 creating a certain discomfort in the viewer. The piece demonstrates one of the most intriguing aspects of ordering information-the need to be aware of an audience's knowledge and experience, which in this case probably taps Hav Setter into memories of school. that time is never fair pokathow it stipslay foul much more abuse elos rekulle a will the body bear there's nothing is nothing's ever really fair 601 + 108

ART DIRECTION	PHOTOGRAPHY	ILLUSTRATION	
	LENG SOH	LENG SOH	
THE OBSERVATORY	PANN LIM	PANN LIM	LESLIE LOW
CLIENT	DESIGN	TYPOGRAPHY	COPYWRITING

ART DIRECTION PHOTOGR PANN LIM PANN LIM LENG SOH LENG SOH ROY POH

lectric quiter

ILLUSTRAT PANN LIM LENG SOH

97 IMAGE DRIVEN

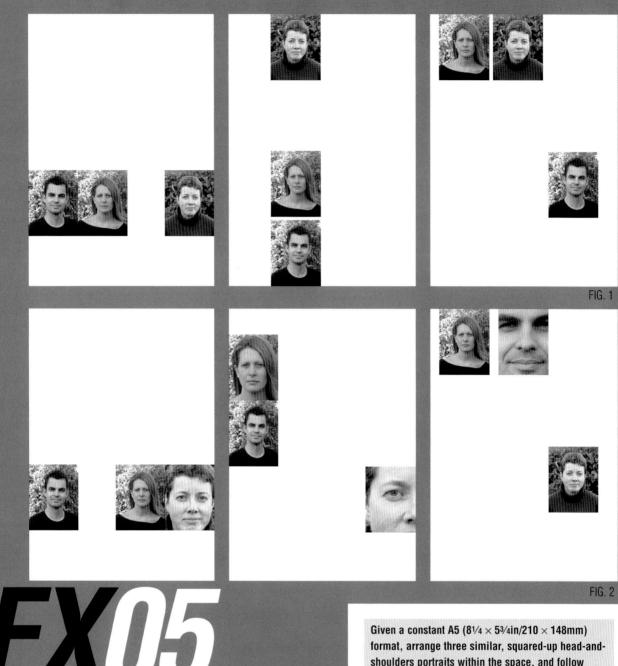

EXERCISE FIVE

CROPPING AND CHANGE OF SCALE

Subject matter does influence the order of perception, however, the

way in which designers use imagery can increase hierarchical control, whatever the content. This exercise seeks to isolate some of the basic principles of layout that can affect the order in which images are seen, such as spatial distribution, groupings, and changes of scale. Essentially simple alternatives, in many cases with minimal changes, are able to impact upon hierarchy. Given a constant A5 ($81/4 \times 53/4in/210 \times 148mm$) format, arrange three similar, squared-up head-andshoulders portraits within the space, and follow a three-stage sequence of changing parameters. All images remain in black-and-white to avoid the influence of color. Cut-outs are not an option.

1. Keep all three image boxes portrait, $11/2 \times 21/4$ in (40 \times 52mm), and the size and cropping of the portraits inside the boxes the same as each other. The positioning of the three elements is the only area for manipulation.

2. As above, but this time you can change the scale and cropping of the portraits inside the boxes. Repeat compositions from part 1 to observe the differences in hierarchy.

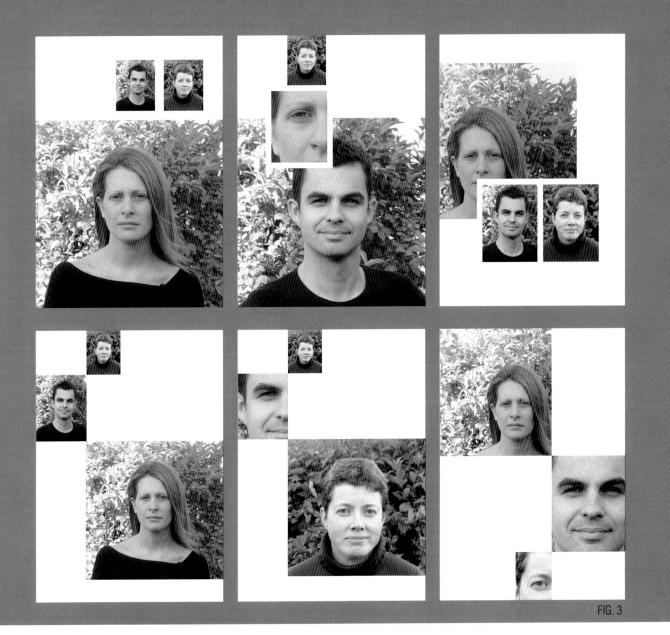

3. You can change the size of the image boxes and the scale and cropping of the images. In some instances the largest image will dominate, but you will gain most from this exercise if you use space constructively, for example, by aiming to make the smallest image the most prominent.

In Fig. 1, distancing one image from the other two appears to draw attention to it. However, positioning images approximately two-thirds of the way down a composition also seems to provide a comfortable eye level for viewers, and the top image of the two sitting close to each other will be viewed first of all. Fig. 2 confirms that positioning is important, but suggests that larger images, particularly when closely or unusually cropped, will generally dominate more distant shots.

Fig. 3 confirms that there are infinite alternatives; the few shown here demonstrate that scaling and positioning follow the same pattern as in figs.1 and 2, but that it is very difficult to reduce the impact of large, framed pictures. Overlapping images, physically bringing them to the front, appears to be a successful device, although it is most effective when white space separates elements.

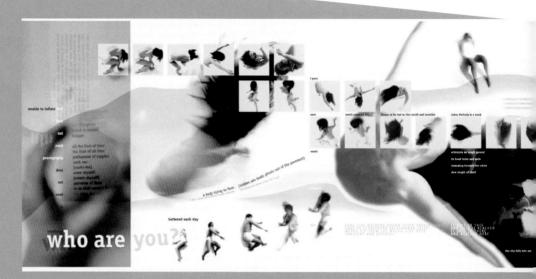

16

CLIENT PHOTO '98 YEAR OF PHOTOGRAPHY AND THE ELECTRONIC IMAGE TYPOGRAPHY DOM RABAN

ART DIRECTION DOM RABAN PHOTOGRAPHY PAULA SUMMERLEY

DESIGN

DOM RABAN

EG.G BODY:INK PUBLICATION

A vibrant interplay of text and image runs

through both sides of this publication, which explores the relationships of body, text, and image. Because the imagery is predominantly of the human form, it is very strong and dominant. Exciting contrasts of scale, dynamic angles, and bright colors are particularly alluring, but it is interesting to note that even the monochrome, squared-up strips of shots draw the viewer's eye, because they are of people.

bodyink

who are

GR/DD GRAPHIC RESEARCH DESIGN DEVELOPMENT Making dramatic and impactive use of deep-blue and high-contrast imagery, MACCORMAC JAMIESON PRICHARD (MJP ARCHITECTS) WEB SITE

Making dramatic and the concept behind this Web site is based upon

layers of frosted glass, a material that MJP frequently use in their work. "This site contains a high amount of text- and image-based information," says James Bowden of GR/DD. "The aim of the site is to deliver information in a clear and concise way, enabling the user to move fluidly and jump from any info layer back to the main menu," he concludes.

CLIENT MJP ARCHITECTS	DESIGN Simon Yuen Julien Depredurand	TYPOGRAPHY JAMES BOWDEN	COPYWRITING MJP ARCHITECTS
ART DIRECTION	PHOTOGRAPHY	ILLUSTRATION	
JAMES BOWDEN	MJP ARCHITECTS	JAMES BOWDEN	

Offices & Com

R Unbu

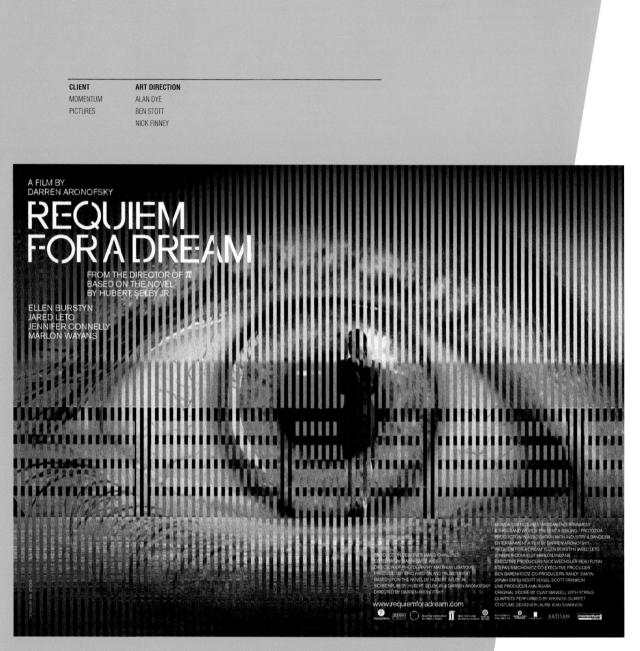

NB: STUDIO REQUIEM FOR A DREAM FILM POSTER NB: Studio have taken two images from the film *Requiem for a Dream* and spliced them together, interweaving them with a

third typographic element. The resulting poster has a slightly disorientating effect, with both images being visible at the same time, in the same space. Although the viewer is aware of both shots, the close-up of the eye, due to its vast scale and centered position, is most dominant, appearing almost as the center of attention for the figure looking into the distance in the second image.

CLIENT WAITROSE DESIGN PHOTOGRAPHY ISABEL ABBOTT VARIOUS

WAITROSE

WAITROSE SELECTIONS, APRIL

In the April edition of Waitrose Selections. mouthwatering enticement

is at work-stunning food photography and styling irresistibly attracts the reader. From the very outset, Isabel Abbott has established a consistent spring color theme of yellow and green; even for the contents page products are shot to reflect this. Items are also shown in enticing contrasting scales, with small things, such as boiled eggs, appearing in enlarged, close-up glory, while brightly colored Easter eggs are featured grouped, at a smaller size.

Pages 6 and 7 of the magazine develop the color theme, featuring green in a deeper tone in a striking photograph of tomatoes. This stunning image is quaranteed to draw the reader's eye away from the heading and the associated explanatory text.

Organic Piccolo This small firuit is ripened on the vine to produce a bright red/orange colour and deep glass, but it is the Bravar, that makes the voriety so special. A very high sugar content combines with a good texture to make a quick and healthy snack. Or try roasting on the vine.

Petite Cherie

se small, teardrop-shaped to se small, teararop-snapped romatous are sweet an y. They have a softer texture, both inside and out, in some larger varieties. They are also surprisingly ust, and are ideal for adding to a lunch box : hamper. Perfect for snacks and summer Try them in salads or on kebabs.

o red these he

acidity, which gives a full, smooth ened on the vine for a rich flavou rve grilled, stuffed or sliced with st ng Chedda

is large classic formato, on the vine, has a full fit and mouthwatering juiciness. It is wonderfully swe ith a distinctive aroma and a softer texture that any standard classic tornatoes. Serve sicced with tozzarella and drizzled with balsamic vinegor. - 6. H FL

Organic Sultan's Jewel

Organic Suttan 3 (were) (his medium-sized, plum homato has a ribbed, slightly quared-off appearance and is sold on the vine. It is inch red colour, largely as a result of being ripened on the vine. This also ensures a full-bodied, rounded Try roasting in the oven with olive oil a

Organic Admiral

IN SEASON 7

Organic Sultan's Jewel

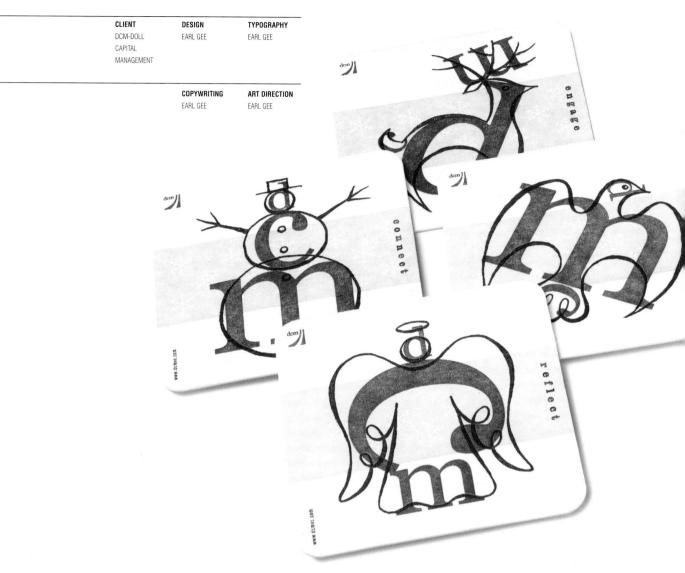

GEE + CHUNG DESIGN DCM HOLIDAY COASTERS

In contrast with the traditional venture capital holiday card, this set of coasters provides a functional, and more memorable

way of sending season's greetings and, at the same time, promoting the company through its initials—DCM. "Our solution layered the firm's initials with line drawings of a snowman, a reindeer, an angel, and a dove, expressing the company's core values of relationships, experience, performance, and opportunity," says Earl Gee. In many respects the bold, bright red letterforms dominate, but because they so cleverly relate to the shapes of the holiday themes, it is likely that the latter are seen first. Icy blue bands containing white snow crystals run behind the images, and these also play a part in making the seasonal subject matter the focus of attention.

CLIENT SURFACE MAGAZINE COPYWRITING

ART DIRECTION ILLUSTRATION

DESIGN

Petals to the metal

Is Frank Gehry an artistic wonder or just the Bilbao bully? Panama is about to find out BY PAUL YOUNG A start of the har any monotors of the second secon

> with being in artist size Anzonia Gardi people secucidad hear basis see: his means designs accur) too years ago. That if years to do with the tepretrip of his wordling means with the operating of his wordhis harvaper Cognitive means in the his may are adougn databased in the genuines in the syst – a dougn databased in the genuines in the syst – a dougn databased in the system of the means the princip databased in the system tem cause Discovy Hall in Lan Angelon rether base Discovy Hall in Lan Angelon rether system and the system of the system Allows in the Seguel Yeit databased to base

 The organ. It'l despite bring plan than Silbao – the hy virtue of bring a mosemen, in archinaux, whereas Disney Hall down to precise orchesical ad do – it knowed out to be too aer- nillar to vicioit the kind of interese, sie that Bilbao did.

The two plot theory with Cody viant Grant and Cody Viant Cody Viant

architecture

EXQUISITE CORPORATION PETALS TO THE METAL MAGAZINE FEATURE Neil Shrubb's colorful illustration of Frank Gehry's new Panamanian building dominates the pages of

"Petals to the Metal." Brightly colored rooting structures, originally inspired by the flora and fauna of Panama, attract attention while the surrounding white space accommodates a large heading, which is seen second. The article itself, also sitting upon panels of white space, makes up the third layer of this "sandwich."

spiracesterically rather than contagnish. Normbeliesa. Pure the D vidal cellents in put th Normbeliesa. Pure the D vidal cellents in put th Normbeliesa. Pure the Normbeliesa in the

Oversetty or ranking and the gammanes
 Tropical Bearsch Instruct.
 That impose seemably led Gebry to tracel
 That impose seemably led Gebry to tracel
 Internet of the optics's flow and to congets - a
 Internet and the conduction of the optical sector of the optical sector.
 They in Conducting the colors of the optical sector of the optical sector.

result of a long evolutionary process. He began by recreasing a model of the site plan, and figuring out exactly what was needed as far as >>

105 IMAGE DRIVEN

CLIENT SURFACE MAGAZINE

IN THE PARTY OF THE PARTY OF THE HAR STILL IT AL AL

> ART DIRECTION PHOTOGRAPHY TORKIL GUDNASON

DESIGN

LAUREN SCHULZ

RILEY JOHNDONNELL

EXQUISITE CORPORATION SEEING THINGS, MAGAZINE COVER AND ADVERTISING FEATURE

In the introduction to this section we suggested that, above all else, viewers are drawn to facial features as

the main focus of their attention. This cover and article from Surface magazine issue 47 provide excellent examples of how difficult it is for viewers to resist meeting a photographic gaze, and demonstrate why so many magazine covers include images of faces. Torkil Gudnason's skillfully directed and tightly cropped images, despite avoiding direct eye contact with the model, are still able to expertly direct and hold the viewer's interest.

PAGE INNO

RECIAL ITALIAN FUTURIST PORTFOLIO

JE

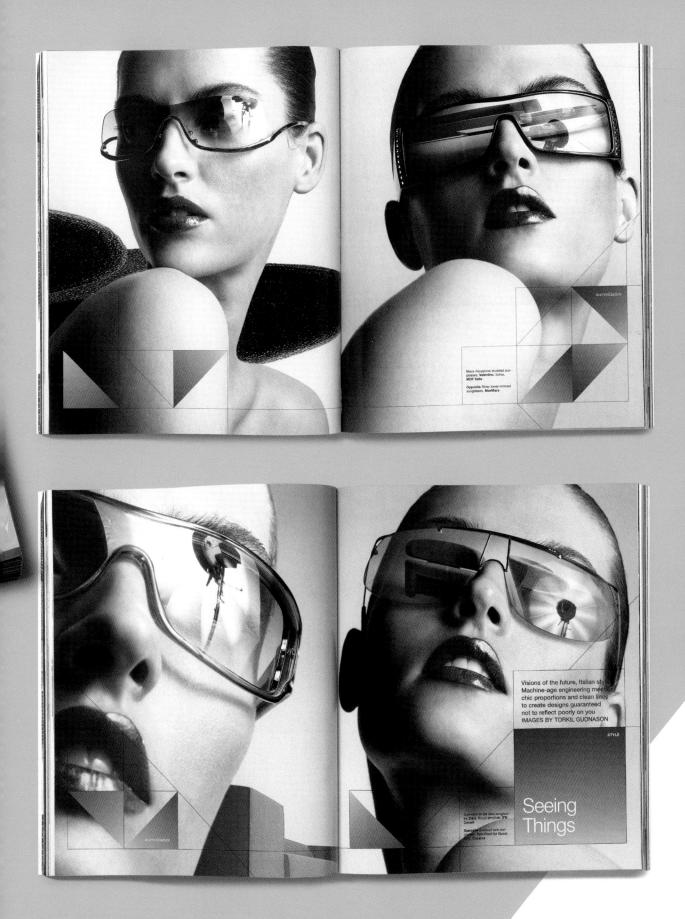

CLIENT CENTRAL SAINT MARTINS COLLEGE OF ART AND DESIGN	DESIGN SIMON YUEN JULIEN	TYPOGRAPHY JAMES BOWDEN	COPYWRITING CENTRAL SAINT MARTINS COLLEG OF ART AND DESIGN
ART DIRECTION JAMES BOWDEN	PHOTOGRAPHY CENTRAL SAINT MARTINS COLLEGE OF ART AND DESIGN	ILLUSTRATION JAMES BOWDEN	

As we mentioned in the introduction to this section, the human figure and face can have a striking effect on the impact of a design.

Undoubtedly, the most dominant single element of these pages from GR/DD's CD for Central Saint Martins College is the silhouette interacting with imaginary touch screen technology (from inside the screen). Regardless of scale, this T-shirt-wearing male figure still arrests the viewer, due mainly to its density of color and deepness of tone.

Directing BA Honors Draws carter bandon ar Control Start Marine The area reading induces as done program opens references, which are an analysis to kind predaction of the antigenesis.

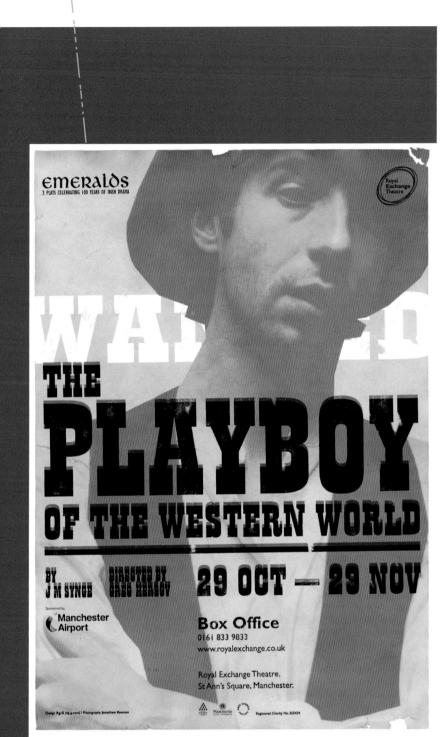

EG.G THE PLAYBOY OF THE WESTERN WORLD THEATER POSTER Eg.G have dramatically merged image

and text in this poster to attract the attention of passersby. A closely cropped photograph of the hero is viewed simultaneously with large, slab-serif type that runs both behind the head and across the chest, where tonal values make the words almost indistinguishable. After the initial impact, a number of levels of information emerge, from smaller type containing further details, to visual references of the American Wild West and its unsophisticated, "oldfashioned" printing techniques, including misregistered colors.

CLIENT	DESIGN	TYPOGRAPHY
ROYAL EXCHANGE	PAUL	PAUL
THEATRE	HEMMINGFIELD	HEMMINGFIELD
MANCHESTER UK		

ART DIRECTION
PAUL
HEMMINGFIELD

PHOTOGRAPHY JONATHAN KEENAN

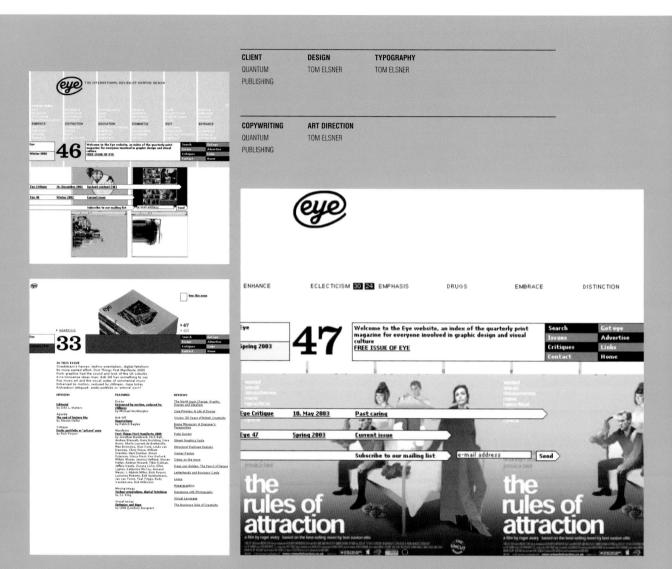

The *Eye* Web site is an index of current and past issues of *Eye* magazine and includes a monthly critique on contemporary issues.

Each page has an enticing and changing style, for the most part due to varying use of imagery and grid. Always acting as a starting point for accessing pages, and often linked to navigation systems, images have a colorful mix of scale and positioning.

The interactive index allows the viewer easy access to the entire range of back issues, and with such a variety of designs within their pages, large numerals, color coding, and a consistent design approach have been adopted to instantly inform the viewer as to which issue is displayed.

Honsouth hypothysis Marco and Alexan Alexan David and Alexan Alexan Alexan David Alexan Alexan Alexan David Alexan Alexan David Alexan

Dear fellow investor

any of the overage boson profess in open with wandler shark it was not open control to the monitor for statement or strateging the page, we wandle dotted to the notice of the observation of the statement of the statement of the observation of the statement of the statement of the statement of the protocol or specific instance anguage granted. Moreoverging and low relatives and the specific open networks and with observation and and the monitorial and depends on networks and with observation and and the monitorial and depends on networks and with observation and the monitorial and depends on networks.

class the besting in webbing relation on the UK recommends of the mering in the relativistic lenders of second, second, concerner preservation, and of bostnesses. Understore the concerned associated and any the further modern and the concerned associate for the further and the second as the further method.

namere products, we give such by a Comparable to one and profiference on and ecosymmetry methods. The shows a profit of methods The means that as here provided by an antidal interpolation of an application and a such experiment lateration of the CS shows reating a neutral confidence above the second and the second application and the second application of the second second second second second second second second application of the second second

SAS MFI ANNUAL REPORT Creating a design that will be noticed and

remembered was one of the primary aims of Andy Spencer and the team from SAS. The "true life" photographic record of the Spencer's stay in one of MFI's stores features prominently in this report, avoiding the usual shots of key management personnel and achievements from the previous year. The reader of the report cannot help but be drawn to the photo album–style pages that chart the family's stay, if only to see humorous interaction with the public, or to find out if sullen daughter Hannah warms to life in the MFI goldfish bowl. **WILSON HARVEY** "This brochure JAMES MARTIN INSTITUTE OVERVIEW is not designed

to be read from

cover to cover," says Paul Burgess from Wilson Harvey, "but to convey a feel of what the institute is about." In order to achieve this, predominantly large-scale black-and-white photographic images stretch across the pages, oozing quality, power, and innovation. On each spread these shots, whether of architecture, people, or landscapes, sweep the focus around the composition to take in small, full-color images; information highlighted with orange; captions; and text.

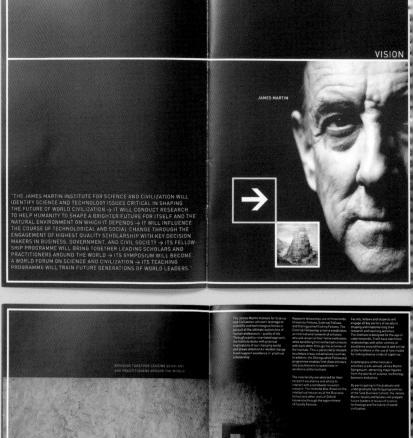

CLIENT JAMES MARTIN INSTITUTE

WILSON HARVEY

DESIGN

ART DIRECTION PAUL BURGESS

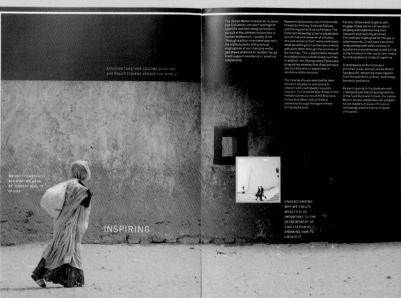

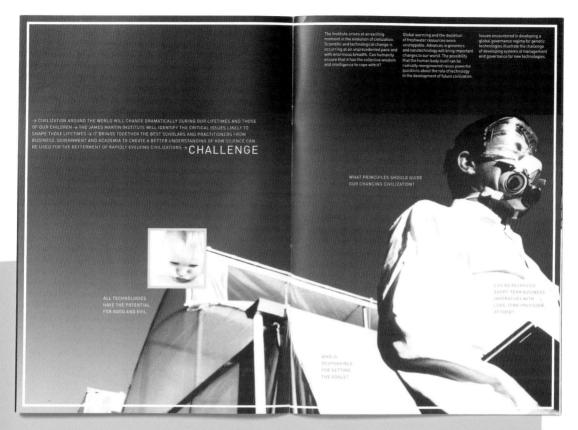

UNDERSTANDING WHY WE CREATE WEALTH IS AS IMPORTANT TO THE DEVELOPMENT OF CIVILIZATION AS KNOWING HOW TO CREATE IT.

Attention to the finer aspects of content and structure is demonstrated by this section taken from one of the spreads. A squared-up inset shot invites the reader's attention initially, as it sits on the same eye-level as a figure in the main photograph, and is framed by a light orange border. It then holds their attention because it embodies intriguing contrasts of scale and a reversal of the black and white in the large image, with two tiny, almost black figures set against a curved expanse of white wall. Cohesion and coherence are further achieved through subtle repetitions of the square format—in the windows of the white building, in the old wall of the main shot, and in the proportions of the block of text.

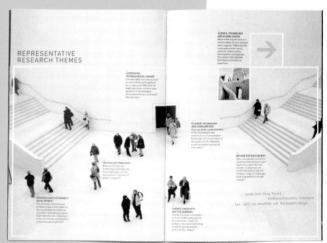

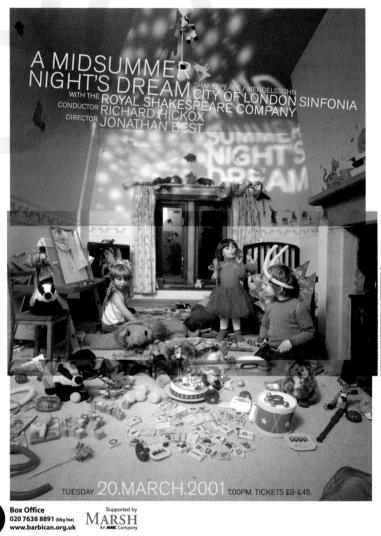

EG.G A MIDSUMMER NIGHT'S DREAM CONCERT POSTER A lively mix of bright colors attracts viewers

to this poster, which at first glance portrays a child's cluttered bedroom. A wide audience can identify with this familiar scene, and because the principle typography has been projected onto the wall of the room, it is perceived as an integral part of the image, achieving a striking advertising poster. As Dom Raban of Eg.G explains, "On closer examination, every element within the room is a coded reference to Shakespeare's narrative." An exciting part of creating different levels of information is being able not only to hold interest, but also to heighten intrigue so that the design becomes interactive, memorable, and, in this case, successful in enticing viewers to read the functional information, and attend the play.

CLIENT DESIGN CITY OF LONDON DOM RABAN SINFONIA TYPOGRAPHY DOM RABAN

ART DIRECTION DOM RABAN PHOTOGRAPHY Gavin Parry

114 EFFECTIVE VISUAL COMMUNICATION

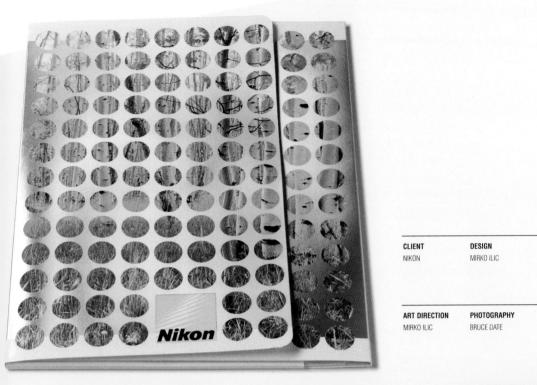

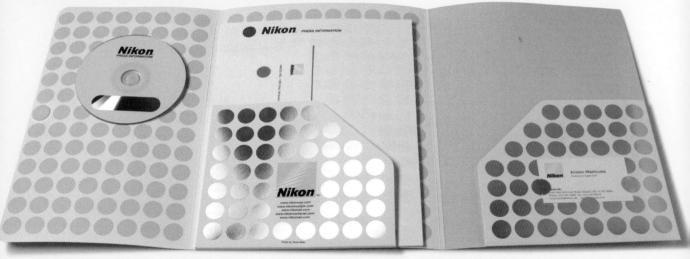

MIRKO ILIC CORP

"This Nikon press kit had two objectives," says Mirko Ilic. "To catch the eye of the audience, and to play with the element of light, since cameras and photography are based on light." It is probably the synergy of repetitive,

patterned circles on a holographic foil that attracts initially, as it is unusual and constantly changing depending on the environment and on the viewer's movements. However, two "need to know" questions are triggered; who is this piece for, and what is the image in the color-coordinated circles? The namestyle and brand colors of Nikon are likely to be perceived next as they are familiar, and the landscape image that runs as though behind the circles is finally recognized through intrigue and sheer persistence. The opened folder works cleverly with variations on the established visual theme. Pockets printed with holographic dots contain sheets of letterhead paper that have "the landscape dots" printed on their reverse, and a large yellow circle—a CD—is affixed on a background of yellow dots.

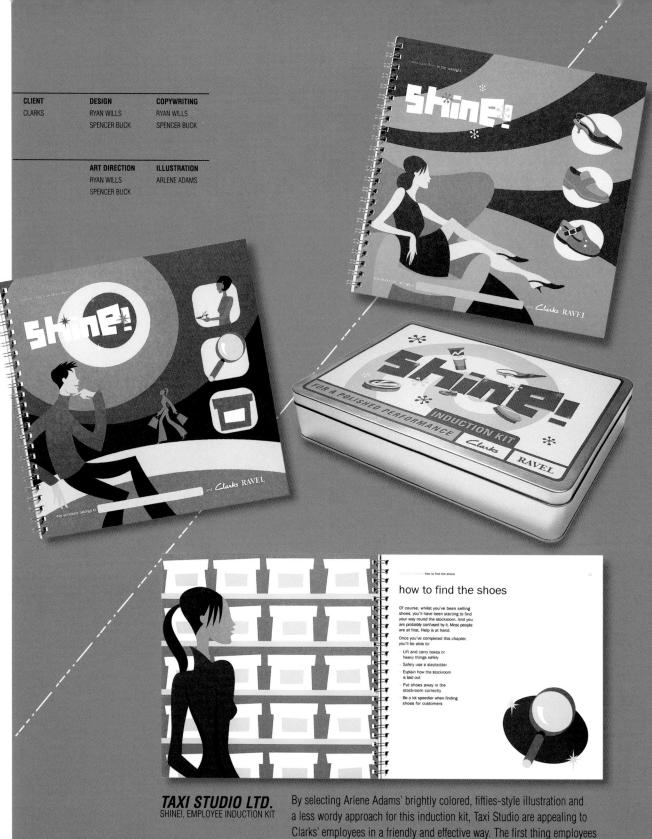

will see are the bold images; dominating each spread (they fill at least 50 percent of the space), these are created with large areas of flat color, drawn from a limited palette. The supporting copy is seen next, printed in small, black, sans-serif text, with headings all in lowercase.

CLIENT GREENWOOD PUBLISHING

DESIGN AMY KWON

ART DIRECTION L. RICHARD POULIN PHOTOGRAPHY DEBORAH KUSHMA

POULIN + MORRIS INC. THE SOCIOLOGY OF MENTAL DISORDERS, BOOK COVER Poulin + Morris' cover design for *The Sociology of Mental Disorders* uses two different images of the human head—one an x-ray, the other a closely cropped portrait—to arrest the reader. The images are printed in contrasting colors and type is kept to a minimum. The viewer's focus is drawn first to the

dark blue portrait and book title; this sits upon a mustard background that accommodates the x-ray. This x-ray, an image of a scull, is seen next, along with the author's name.

CLIENT	DESIGN
THE WIRE	KJELL EKHORN
MAGAZINE	JON FORSS

KJELL EKHORN JON FORSS

TYPOGRAPHY

ART DIRECTION KJELL EKHORN JON FORSS

PHOTOGRAPHY JO ANN TOY ROBERT GALLAGHER ANNA SCHORI

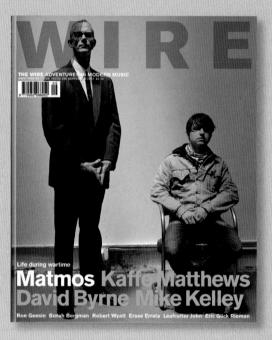

This issue of The Wire magazine features many very striking full-page

portraits, all of which grab the reader's attention ahead of any type. Viewed next, even headings take on an image bias, as they are embellished illustratively with silhouetted snippets of fraying fabric to create a complex, delicate, and somewhat organic effect. Completing the three layers present within these spreads, smaller, introductory text is seen after photography and headings.

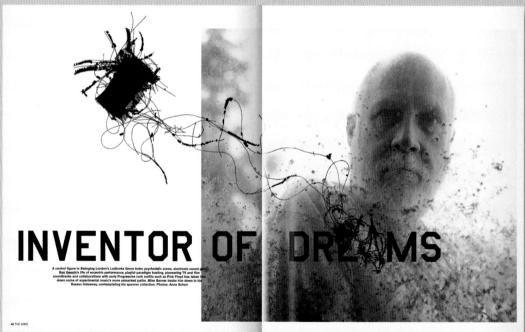

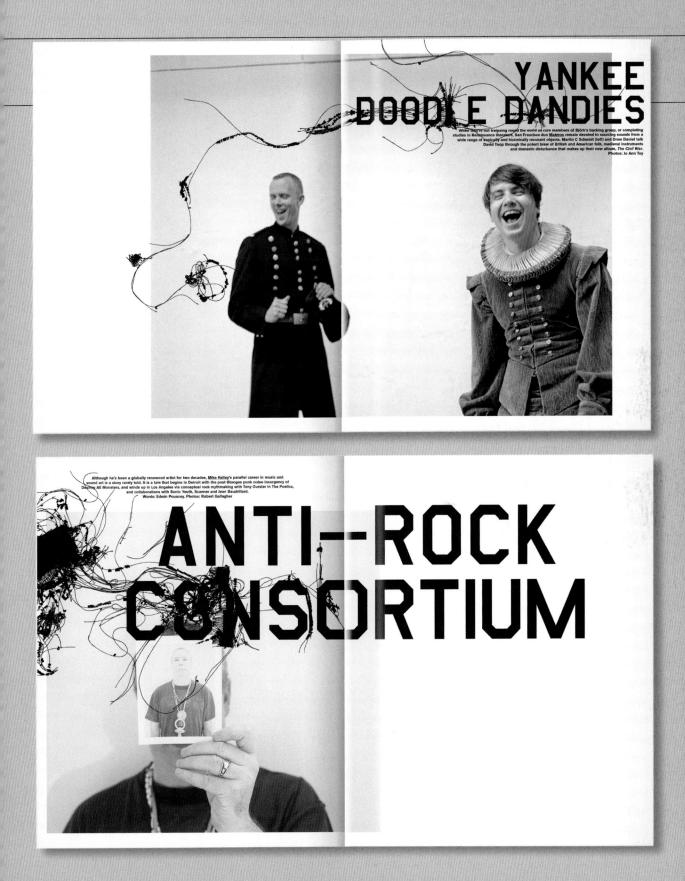

CLIENT TATE BRITAIN

DESIGN

NICK VINCENT

ART DIRECTION ALAN DYF BEN STOTI NICK EINNEY

Admission free 26 February - 26 May

Tate Britain London SW1 • Pimlico www.tate.org.uk

NB: STUDIO DAYS LIKE THESE

Reminiscent of London's Underground

map, the brightly colored, swirling lines that make up the main focus of this design for Tate Britain's Days Like These exhibition are not only very prominent, they also act as an effective wayfinding system. "The show features the work of 23 British artists, and instead of being located in one distinct gallery, the pieces were dotted throughout the Tate," says Alan Dye of NB: Studio. Certain designs, like the London Underground map, have become icons, and are instantly recognized by UK citizens and visitors alike; if designers can tap into their familiarity by replicating distinctive aspects, they can also take advantage of their ability to attract attention. Each item clearly belongs to the same set, with different sections of the enlarged, colored network taking center stage, in a position of primary focus.

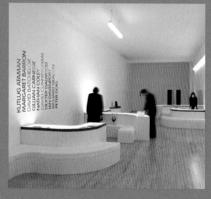

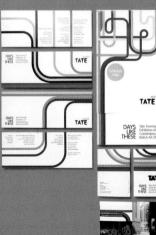

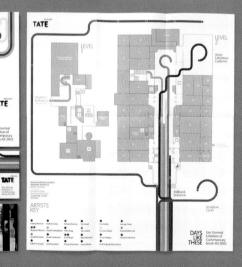

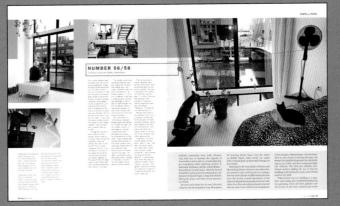

DESIGN

ABBINK

COPYWRITING JEANETTE HODGE JANE SZITA

ART DIRECTION PHOTOGRAPHY MARTIEN MULDER JEANETTE HODGE ABBINK

PHOTO EDITOR MAREN LEVINSON

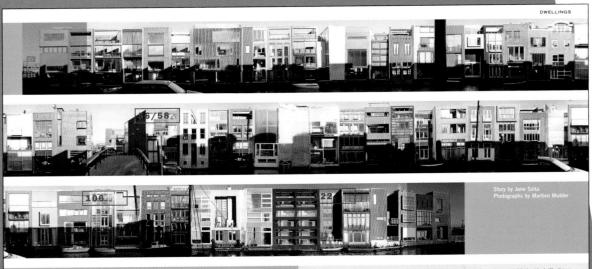

STRAAT OF DREAMS

On Borneo Island's Scheepstimmermanstraat, in old Amsterdam's newest neighborhood, it's modern architecture's Golden Age.

62 dwell series

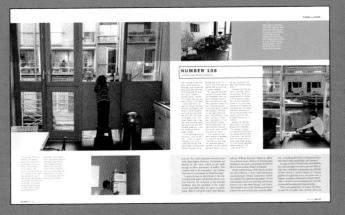

DWELL DESIGN DEPT. STRAAT OF DREAMS, MAGAZINE SPREAD

The horizontal row of brightly colored, terraced houses together with the blocks of orange and blue

immediately attract viewers to these spreads. Due to the comparatively small scale, the initial perception is purely one of an exciting mix of pattern and carefully selected colors. The impact, however, is sufficiently powerful to secure most readers' desire to decode the content of the images alongside main headings, and finally to embark upon the text.

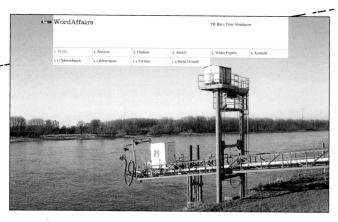

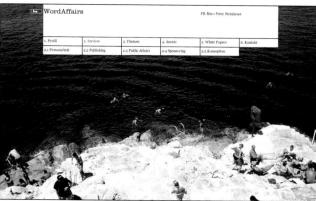

BUREAU FOR VISUAL There is no doubt that the striking landscape imagery WORDAFFAIRS (BFVA) striking landscape imagery WORDAFFAIRS WEB SITE AND IDENTITY used in the WordAffairs Web site is hierarchically dominant. "The Web site splits the aspirational image-based content and the pure information into two separate entities, while the content remains easy to access, read, and navigate, and the imagery is given space and prominence," says Simon Piehl of BfVA.

CLIENT	DESIGN	TYPOGRAPHY
WORDAFFAIRS	SIMON PIEHL	SIMON PIEHL
	TOM ELSNER	TOM ELSNER
COPYWRITING	ART DIRECTION	PHOTOGRAPHY
 COPYWRITING WORDAFFAIRS	ART DIRECTION SIMON PIEHL	PHOTOGRAPHY SIMON PIEHL

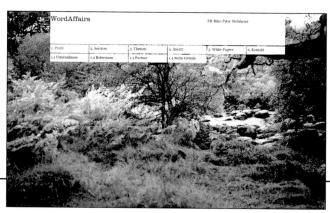

WordAffairs				PR-Bito Peter Steichauer		
1. Profil	2. Services	3. Themen	4. Ansatz	5. White Papers	6. Kontakt	
Zielgrup	ppe: Medien		1	Aktuell		
WordAffairs hietet ein professionelles Dienstleistungsangebot in den Bereichen Public Relations und Public Affairs. Vir konzigieren Medirekangugen, schreiben Prese- und Werbetetet oder beobachten und analysieren für Sie die politische Agenda in Berlin.			Berlin, Januar 2004 lan Januar and die Supporter von Mehannung die Belander gesternten der Verlander der Bendertug songenernter Verkehreident von die Spektremig, songenernter Verkehreident von Hefennammennen die Personentierter von MAS, IF Admensi aufer Praardigert von MAS, Berlander von die Statistichten Massel und georgeneiten werden. Unterschieder die statistichten werden. Unterschieder			
Unsere Arbeit verschafft unseren Kunden eine hohe Aufmerkanalweit in der öffentlichen Wahrnehmung und eine aktive Rolle in der Kommunkation mit ihren Anspruchagruppen. Falls Sie Fragen zu unserem Angebot haben, rufen Sie uns an: Telefon: 030-44017046			und Wirtschaftsverti seiner jetzigen Form Berlin/Brüssel, 16.12 Die Kommission hat für die Regulierung i	reter halten das Gesetz in für inakzeptabel. 2003 heute ein Strategiepapier m audiovisuellen Sektor		
				 technische Entwicklu berücksichtigt werde Fernsehwerbung, Juj 	n. Die Vorschriften über gendschutz und Schutz der m im ersten Quartal 2004 Ein etwaiger Überarbeitung der	

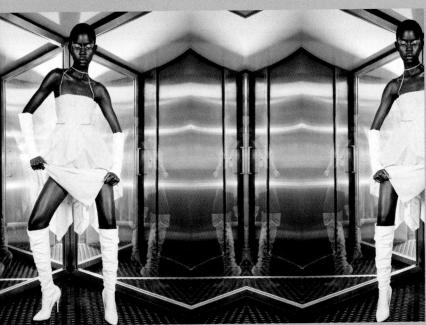

SCANDINAVIAN DESIGN GROUP MUNTHE PLUS SIMONSEN SPRING/SUMMER 04 CATALOG As with many fashion catalogs, the Scandinavian Design Group's work for Munthe plus Simonsen's spring/summer 04 collection features primarily image-based

design. However, unlike many other pieces, images and backgrounds have been manipulated to create a kaleidoscopic effect intent on fascinating the viewer and drawing them in to the deepest level of imagery. Models are reflected and duplicated, as are backgrounds, echoing the angles and structure of the clothing featured to create a space-age environment.

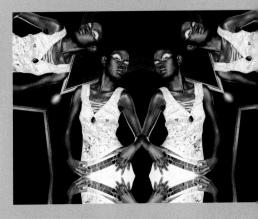

CLIENT MUNTHE PLUS SIMONSEN DESIGN PER MADSEN MUGGIE RAMADANI

ART DIRECTION PER MADSEN PHOTOGRAPHY RASMUS MOGENSEN

	UNIG	ALLERY OF AR
		fall 200
		exhibitions and lectu
		Cambrions and lecu
VISITING ARTIST / SCHOLAR August 27 Terture by Joyce J. Sout, Arth	DECTURE SERIES	Funded in particy the Martha Elley Tvy Young Ariat/ScholarFund.
O-tabler I Learner to Elearner bearing, Writer Critics and Learner.	5-00-PM, KAR-114	Elemon Heariney is Januer for the 4 Ownerine of Farth exhibition. The exhibition is sponsored by the UNIVERSITY OF 100 A COLLECT OF UPLEXITOR. He UNIDERATIVITY OF AND and the journal Religion and Education Opening Reception is follow the Verture of A OP M.
October Lecture by Par Olesko, Perfort October II Performedia Nick Scientific, Point		FTH IDANST ELECTURE SERIES. Funding for the former series is provided by the Meryl Norton House Chair in the COLLECT OF ID MANTERS AND LINE ARTS.
Grouper a precurring Sick Joseffan, Ports		Del Roching far a find innor anticla years when how in Pochanda, Neuch et anticas. The revenued has MA beam familiants of more first insulant workshown biomythican the courses (including the courses) who and affany familiants (admet). Monutants Selved of Catalas. The will be every a workshow from 300.004. Nova & 1000 - 4000 PM on Devader 8 a 5 a 7 Morthan Ellen Fix Visiting Antice (Selved Final).
EXTUDETTONS August 27 - September 21 – Joyce J. Sout Journeys	Opening Reception 7:00 - 8:00 PM Monday, August 27	
		April 2 Sort Journey Is an edilitikin of Jope E Sont's treast work in them glass, up a glass, basebook, and printing The Bahaman-Isand antis' is a discussion of Mono-Americans. Native Instruments and System, many of Johan waves oppliers, balance and wave and and and apply associate. The work often errors is summaring an examingance is minim. Voltence across and aurocapper. Socie is the recipient of more those from the National Ladowards for the Partice Instrument and an environment of the foreign and all more than the National Ladowards for the Partic Instrument Refer Permittion and the Sactional Cost Americk.
higher 27 - September 21 Note in Doors 1 - one 20th Ger halo end and Architectural Di	nny Grophie.	Modern Design Janus 2006 Cratinge Orughie, Industrial and Architectural Design Jonness well-known classic objects (De exhibit is warrand) for by B. Behrens, NJ: professor of erg, show more remet ISA Galwey al. Yet design exhibition (d). Design and Cranofflage. More Design Jonnessments down 25 prove that include the recarging of looks, part warsaging, dimension and even pass, Attify works on glogdy include that of L-Carlmeier, Joef Alney, Mahn Gaise May Court, De Hagging, and United and Design 2019.
October 1–20 A Question of Faith	Opening Reception 7/00 - 4:00 PM Monday, October 1	
Navender 1 - Doernlar 2 2001 Department of Act Facult		A function of Faith is an all mode, national proof exhibition exploring a multitude of viewpoints concerning talignes. The power is the chatagonabul writer, leavers, and an erise. Flowout Flowrups, a controlluting claims of faith increase, relations in the should be dest to faith of a faith of the faith of the faith of the faith of the faith of the DEST of the power of the faith of the DEST of the power of the faith o
December 10 - 21 2001 MA Externa /BFA Ex	Moorday, November 5	The 2001 (Equations of left Faculty Exhibition presents a sampling of the visual accomplications of the faculty in the Department of Art.
Deermdoor I Deer Walsout Art	DNI Laflery should	Becognizing the documentation of ATDS and HDS. Monday, Disconder Lat is recognized nationally as the Day Bitleout Let, Latherise and immediate elevel and dark on that day.
		All exhibitions and Berners at the UN1 Gallery of Art are fore and open to the public. The Gallery is knowed at the com- bined and West 27th spreet in Cedur Falls on the main flow of the Kamsetek Art Beilding.
		for nove information, contact the Collery at (310) 2733-3093 CalleryOfWani Adm review one Windowski and
		9:00 VM to 5:00 PSL Friday Noon to 5:00 PSL Statighty and Statisty.
		Please mate, the gallery will be clusted for the following dates Sequendler 3 Labor Day Normality 21–25 Thank existing Break December 1 Day Williams for
		December 22-January 13 Winter Break

CLIENT DESIGN UNI GALLERY OF PHILIP FASS ART

TYPOGRAPHY PHILIP FASS

PHILIP FASS FALL 2001 UNI (UNIVERSITY OF NORTHERN IOWA) GALLERY OF ART SCHEDULE POSTER FALL 2001 UNI (UNIVERSITY OF ART SCHEDULE POSTER Scale imagery, and five striking, dark blue The passing viewer is drawn to this gallery schedule by its dramatic use of color, largebands sitting horizontally across the center

of the piece. Slightly lighter turquoise tones are used for the giant snowflake and flower images that make up the background layer of this poster. Descriptions of events and program details are not initially evident, but are "easy to read when pausing in front of the poster," says Philip Fass.

DARRELL TAYLOR MARY FRISBEE JOHNSON

COPYWRITING

PHOTOGRAPHY PHILIP FASS

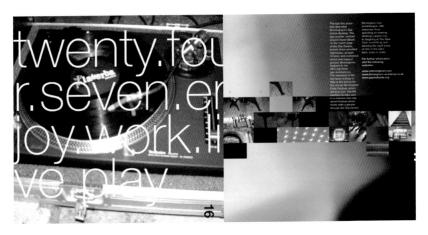

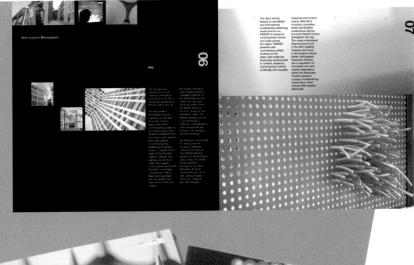

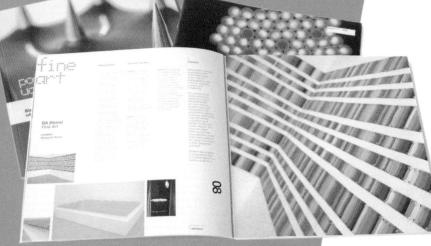

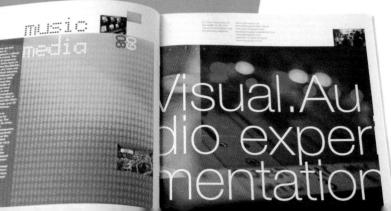

CLIENT UNIVERSITY OF CENTRAL ENGLAND (UCE) DESIGN RICHARD HUNT

SCOTT RAYBOULD

Z3 DESIGN STUDIO INC. UNIVERSITY OF CENTRAL ENGLAND ART AND DESIGN PROSPECTUS Shooting their own digital imagery for this prospectus

enabled the designers at Z3 to focus on many abstract details, while highlighting color and texture. The viewer is drawn first to the colorful full-page shots, often located opposite contrasting, all-black pages. The reader is drawn next to the smaller, squared-up images, which have as much bright color detail as their larger counterparts. Color plays a vital role within this design—bright, acidic hues were sought out by Richard and Scott—though fullpage photographs are always handled so that type, despite being viewed last, is clearly legible set on top of image.

> 125 IMAGE DRIVEN

CLIENT SURFACE MAGAZINE DESIGN RICHARD SMITH

ART DIRECTION RILEY JOHNDONNELL PHOTOGRAPHY TIZIANO MAGNI

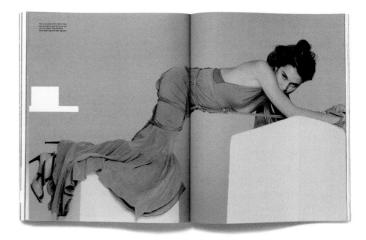

The pages of "Love me Knots" show various models, clad in couture outfits and bound with all of this and the even

different shades of thick rope. If all of this and the eyecatching pair of red wedge platforms shown on the opening spread are not enough to arrest the viewer, Richard Smith has added some striking white, rectangular shapes that cut into the photographs and, as the lightest elements in tone, also attract the reader's attention.

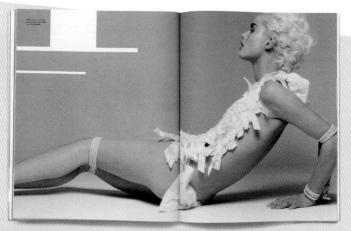

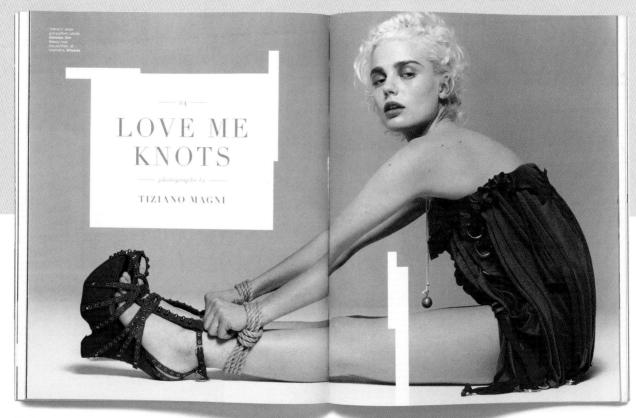

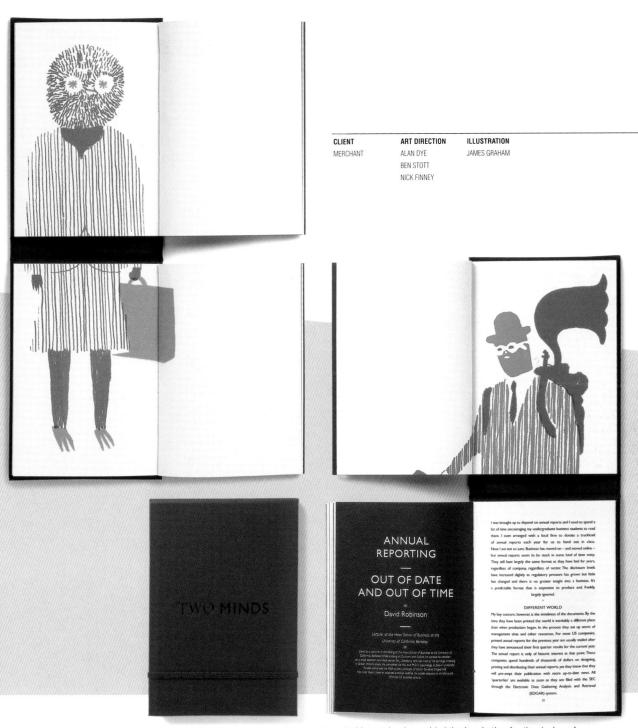

NB: STUDIO TWO MINDS, MERCHANT HANDBOOK 2003 The classic moleskin notebook provided the inspiration for the design of *Two Minds*, the Merchant Handbook for 2003. The cover lifts up to reveal two separate volumes, one above the other, and this format is one of the most

noticeable elements of the piece. Separate spreads from each volume combine to reveal James Graham's lighthearted illustrations and attract the attention of the reader, giving them the engaging task of finding and locating the other half of each image.

				'n	ES	36
N				0	LA	U
í.	P	-iY				

ART DIRECTION

CLAUDIA NERI

CLIENT EVAN DIO PHOTOG

> PHOTOGRAPHY EVAN DION

IA NERI

Jepin Lini abutta

"This is a very image-driven piece," says

Claudia Neri of Teikna Design. "It is aimed at making an emotional connection with the viewer. Text is used as a complement, a personal afterthought, or commentary to the images," she continues. Supporting type is well selected and merges with the imagery; its elegance relates appropriately not only to the style of photography, but also to the subject matter itself.

I have for protect to assume the second start of the second sta

PHILIP FASS PRAIRIE DREAMS EXHIBITION INVITATION

This invitation to Prairie Dreams reflects the exhibition's installation of living plants. The dominant images of prairie grass definitely draw the viewer's attention first, with type playing a secondary, but nonetheless interesting role.

"The type moves through the image in a poetic manner," says Philip Fass. "In the collection of information, the reader's eyes enact a motion across the surface of the card that is related to the movement of wind across the prairie," he continues. Type, though secondary, is easy to access, as the strong use of yellow and green within the photographs contrasts with, and draws attention to, small amounts of blue text located primarily at the upper edge of the page. The expectation of blue skies extending in this position also helps to ensure that viewers read this information.

 CLIENT
 DESIGN
 TYPOGRAPHY

 UNI (UNIVERSITY
 PHILIP FASS
 PHILIP FASS

 OF NORTHERN
 NOWA) GALLERY
 OF ART

 ART DIRECTION
 PHOTOGRAPHY

ART DIRECTION PHILIP FASS

PHILIP FASS GREGG SCHLANGER

Andrew Debens of Z3 has created a new identity and typeface for the group Babes in Toyland, to be implemented across three albums of past, present, and future works.

Designs are dominated by a strong use of color and layered montages of distressed images, with Deben's new typeface being seen second, as a support to this complex and evocative imagery.

"Les Blancs explores the shifting dynamics of resistance and assimilation

under African colonization," says Dom Raban of Eg.G. As a consequence, this theater poster is a collage of numerous and disparate visual elements to reflect the narrative of the play. Certain features appear more prominent because of their scale and tonal definition; however, just as the play is about changing power, so much of the poster is made up of overlays of visual and verbal information that vie for attention, with changing emphasis dependent on the viewer's personal knowledge and experience.

CLIENT Royal Exchange Theatre, Manchester UK

EUROPEAN PREMIER

DESIGN AF DOM RABAN DC JO MORRITT

ART DIRECTION DOM RABAN तः

Oded Ezer's poster has been produced in homage to the work of Israeli visual

communicator David Tartakover. The title "Now" makes reference to the Israeli peace movement slogan, "Peace Now." At first sight, the viewer is confronted by a dense shower of disturbingly sharp nails falling from the sky. However, on closer inspection, a layered effect provides the opportunity to look through this storm and, in the distance, view nails that have come together to create 3-D letterforms.

CLIENT	DESIGN	TYPOGRAPHY	
SELF- PROMOTIONAL PROJECT	ODED EZER	ODED EZER	
ART DIRECTION	PHOTOGRAPHY		

SHAXAF HABER

ODED EZER

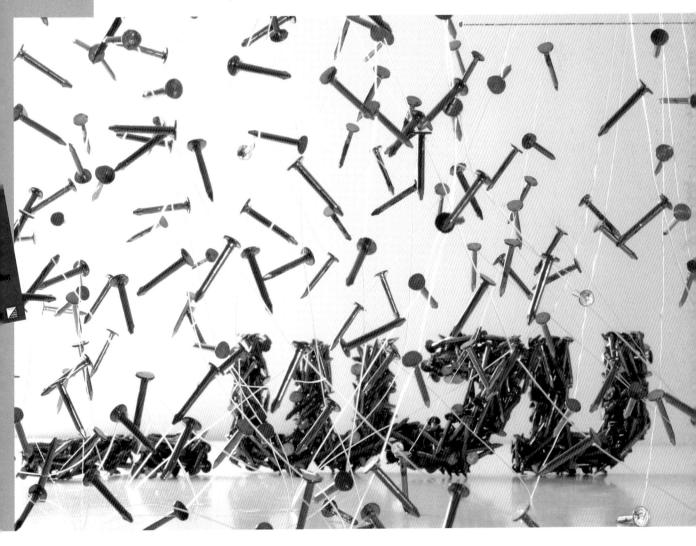

CLIENT	DESIGN	
SPEEDY HIRE	NICK VINCENT	
ART DIRECTION	PHOTOGRAPHY	

ART DIRECTION ALAN DYF BEN STOTT NICK FINNEY

PHIL SAYER

NB: STUDIO SPEEDY HIRE, ANNUAL REPORT & ACCOUNTS 02

By overlaying Phil Sayer's gritty black-and-white photography of Speedy

Hire's everyday activities with type that takes on the characteristics of warning stickers, NB: Studio have created some colorful, eye-catching spreads within this report and accounts publication. The large-scale shots certainly attract the reader's attention first, while the remaining layers of information are provided by a collage of the colored stickers that accommodate copy, each given a different treatment.

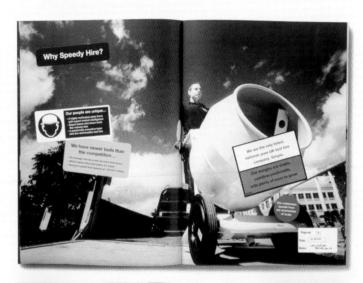

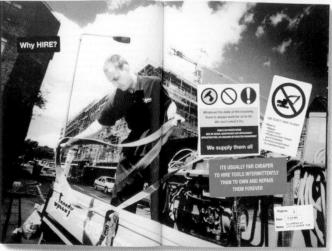

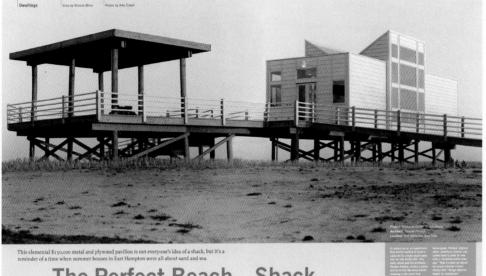

Shack The Perfect Beach

DWELL DESIGN DEPARTMENT

STRANGENESS BY THE SEA/ THE PERFECT BEACH SHACK, MAGAZINE FEATURES

The arrangement of type and tinted boxes in both these spreads is inspired by the color and composition of the images. This establishes the entire layout as the first level of perception, and as one cohesive whole. Colors of words match colors within images, and tinted boxes relate to each other and to text in a way that reflects the constructional character of the buildings. The second level is provided by the

headline type, with the assimilation of body copy coming last.

CLIENT DWELL MAGAZINE

DESIGN SHAWN HAZEN JEANETTE HODGE ABBINK

COPYWRITING VIRGINIA GARDINER VICTORIA MILNE

PHOTOGRAPHY ART DIRECTION JEANETTE HODGE CLAUDIO EDINGER AMY ECKERT

ABBINK

PHOTO EDITOR MAREN LEVINSON

Mixing black-and-white and color photography across the spreads of this miniature brochure for Novo Nordisk has helped The Scandinavian Design Group create some striking spreads. These clearly image-driven pages blend natural landscape with informal portrait photography in a successful manner.

Shots accommodate panels of handwritten script that make up the second level of this design, and more formal panels of lightweight, sans-serif text that make up the third. Another level, created by the gloss varnish is perceived separately and, dependent upon the reader, this can be "seen" at any point in the viewing process

CLIENT NOVO NORDISK SERVICEPARTNER A/S

DESIGN

ART DIRECTION MUGGIE RAMADANI JESPER VON WIEDING

PHOTOGRAPHY MIKKEL BACHE

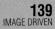

Z3 DESIGN STUDIO INC

entirely imag

for Dance East, by Scott Raybould of Z3, folds and flows to mimic the movement of dance. Images involve dramatic changes of scale, varied cropping, and vivid use of color. As to which image grabs the viewer's attention first, this is likely to be the single, large, bright red image with its dramatic cropping and expansive use of space. However, the other imagery continues to lead the viewer quickly from one photo to the next, in an order that is probably dependent on personal preference.

LIENT DESIGN ANCE EAST SCOTT RAYB

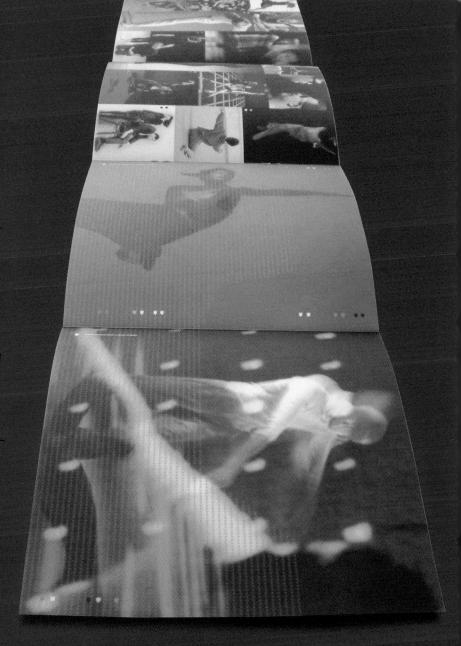

CLIENT	DESIGN	TYPOGRAPHY
THE SHINING	SIMON YUEN	JAMES BOWDEN
	JULIEN	
	DEPREDURAND	

 COPYWRITING
 ART DIRECTION
 ILLUSTRATION
 PHOTOGRAPHY

 THE SHINING
 JAMES BOWDEN
 PAMELA HOLDEN
 THE SHINING

The Story

attention in this Web site designed for the band The Shifting. "We wanted to create a 3-D TV broadcast environment with hidden channels and promo areas such as backstage filming, and videos," says James Bowden of GR/DD. "The user is placed in a TV network environment in which, by using emote-control access, it is possible to explore various parts of the site," he concludes.

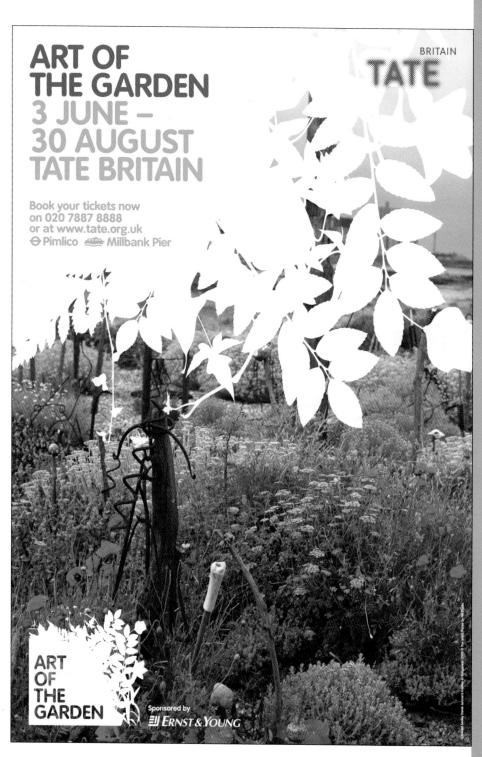

CLIENT TATE BRITAIN DESIGN NB: STUDIO

ART DIRECTION

ALAN DYE BEN STOTT NICK FINNEY

NB: STUDIO ART OF THE GARDEN EXHIBITION POSTER The arresting white silhouette of foliage from an English hedgerow provides

an ideal "nest" for the title of this exhibition at Tate Britain— Art of the Garden. The group of leaves and branches eclipses all other elements, even when vying for supremacy with shots of Derek Jarman's fascinating Dungeness garden. CLIENT MUNTHE PLUS SIMONSEN

ART DIRECTION PER MADSEN MUGGIE RAMADANI

PHOTOGRAPHY HENRIK BÜLOW

FILM PHOTOGRAPHY PHILLIP KRESS

DESIGN

PER MADSEN

SCANDINAVIAN DESIGN GROUP MUNTHE PLUS SIMONSEN AUTUMN/WINTER 2003 CATALOG

The Munthe plus Simonsen autumn/winter 2003 catalog adopted a cinematic approach that has clearly

affected the style and cropping of its imagery, and made it extremely seductive. Lighting is high contrast, often involving the use of colored gels, and images appear to be tightly cropped stills from a movie. The first thing the viewer will notice on picking up the catalog is the glossy, full-color acetate cover that flexes around this hardback issue. This entices them to leaf through the striking image-based spreads. The actual portraits are seen first, with the stylist's detailing and embellishments providing continued visual enjoyment on further levels.

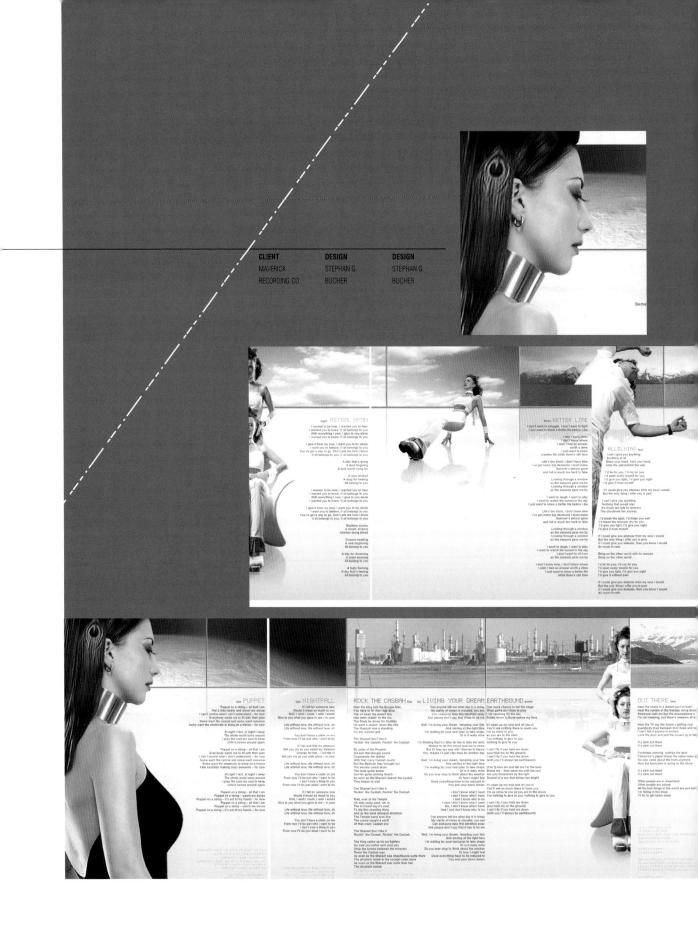

Unusually cropped and montaged images are the most visually powerful elements within this CD booklet design. The way in which Stephan Bucher has sliced figures in half, to provide vertical alignments for type, attracts attention, drawing the viewer into fascinating detailing with semi transparent

sections and an intriguing interplay of foreground and background. Although the text flows in and around the images, as it is comparatively small, it is likely to be read last.

A peacock's feather, skillfully manipulated to blend into a model's hair, is just one of the surprises to be found as the viewer discovers more layers of information.

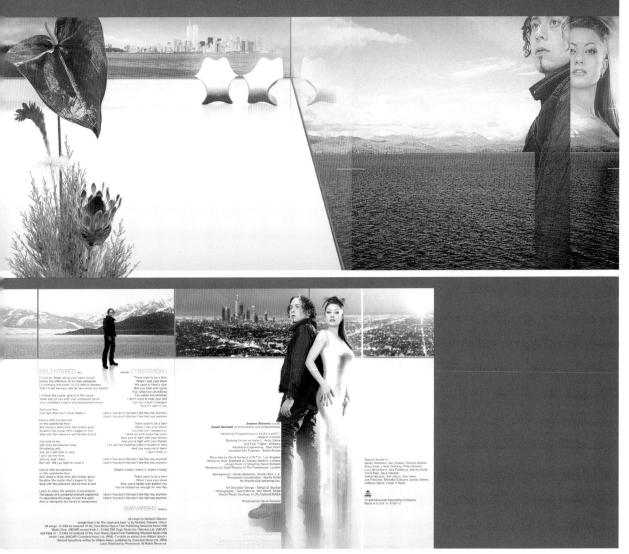

 CLIENT
 DESIGN

 TEMPLETON
 WAI LAU

 COLLEGE
 UNIVERSITY OF

 OXFORD

ART DIRECTION PAUL BURGESS

tenner. It offers a range of open-encolment programmes in the Oxford Advanced Management Programme (AMP) () Oxford Strategic Leadership Programme and, in collaboral HEC Executive Development, Consulting and Coaching for

> In Communications' reported quarters, support times scenarios and temperature potential to the Italian order to savet with relativity Threat page answers (Separath an environment for a sequences (Separath an environment for stranger surgery and College

The extra theorem of the comparison of the comp

WILSON HARVEY TEMPLETON REVIEW

because of its striking and unusual use of photography and composition. Comparatively predictable subject matter has been cropped in unexpected ways to give dynamic shapes that cut into, and line up with surrounding text; each image has been interpreted in a combination of single-color grayscale and fullcolor cut-out sections. The viewer's focus is drawn to the full-color sections, moves out to the monochrome areas, on into the background tints, and finally, with ease and a certain degree of willingness, into the text. With its changes of scale, column positions, and widths, the text is presented equally accessibly.

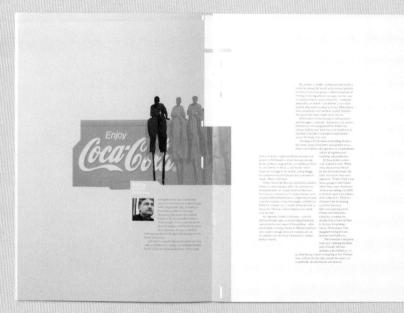

DIVERSITY WITHIN LAYOUT USING TEXT AND IMAGE

Although this book is divided into type-driven and image-driven ordering, this has not

precluded combinations of image and type. This exercise provides an opportunity to consciously explore the ways in which hierarchical roles of both type and image interchange. In the examples below, images, headlines, and body copy come together in varied configurations to demonstrate some of the many possibilities available when designing pages.

Each example includes a constant number of elements that are combined in a variety of ways to create differing visual emphasis. Primarily, it is changes of composition and scale that control the reader's focus and visual route through a layout. This allows the origination of alternative pace and rhythm, and also introduces the possibility of altering meanings. Even paragraphs of text that are generally expected to be read last can be scaled and positioned so as to occupy a position of primary focus.

Photographs can be used as full-color images or as grayscale; type, as headings and subtext, can be used black on white or as white reversed through a background color, tint, or photograph. In order to produce design alternatives that concentrate on the relationships of type and image, it is beneficial to restrict the choice of typeface to the Helvetica family. Overly decorative or stylized typefaces could prove too much of a distraction and might have the effect of reducing the number of more skilled, sophisticated, and considered layout options. Images can be squaredup, cut-out, cropped, scaled, or repeated, and grayscale can be colored in order to highlight or knock back.

Impose the following parameters in the given order:

1. Create a number of image-driven A4 (81/8 \times 1111/16in/210 \times 297mm) layouts, with the image content to be viewed first, the headlines perceived next, and body text to be seen last.

2. Create type-driven A4 layouts, with: a) the headlines reading first, the image content next, and finally the body copy; and b) the body copy as the most prominent element in the layout, the headlines read next, and the imagery seen last.

The benefit of this exercise comes from the experience gained through trial and error, not necessarily from creating the "best" layouts: the process of changing and fine-tuning treatments can provide unexpected results that feed into future work where hierarchical sequencing is important.

Fig. 1 demonstrates one of the many alternatives that can make images the most powerful components within a layout. The examples in Exercise 6 show different treatments that attract even more attention, but it is clearly evident that even when disregarding image content, the depth of tone and scale of images in relation to other elements tend to ensure their dominance. Fig. 2 attempts to knock back the images to third place by overlaying a bold green headline on a single-color, grayscale image, and placing the smaller text in an overlaid white box. The headline catches the reader's attention, leads them to more green in the subheading, and on through all the type to the green concluding paragraph. The prominence of two color images is reduced by unobtrusive positioning and the use of comparable tonal and textural values with the background.

Figs. 3 and 4 are more challenging in that their text is intended to be the attention grabber. In fig. 3, the size of type, and the impact of white through blue and embedded white boxes draw the viewer in, but whether all the information is read before any of the imagery is absorbed is debatable. In fig. 4, the black-and-blue text is fairly large and positioned on an angle to appear more powerful. It may be seen first, but as the pictures are the most easily accessed elements, they will probably be taken in simultaneously.

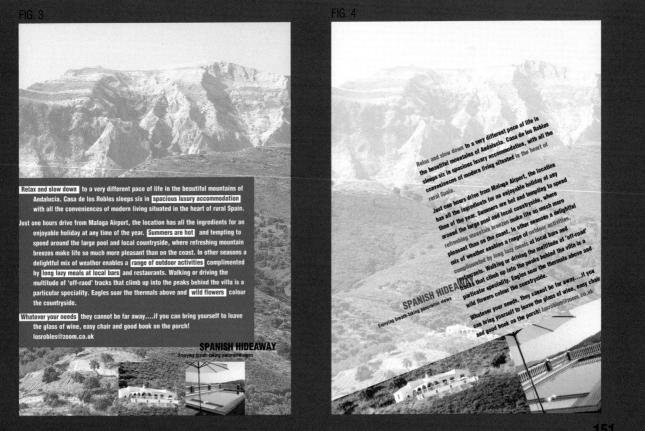

dancew

CLIENT

DANCEWORKS UK

PAUL HEMMINGFIELD JO CARTWRIGHT

DESIGN

ART DIRECTION DOM RABAN

Dramatic cut-out images of energetic dance poses and through the pages of this brochure. The compositions are clearly image-driven, to the extent that even the blocks of text and captions are seen initially as shapes that interact with the figures. Any actual reading of the type is likely to take place only after the complete spreads have been enjoyed as lively and stimulating experiences.

٢S

IN SOUTH YORKSHIRE

FRI.31.JAN ROTHERHAM ARTS CENTRE **RJC DANCE PRODUCTIONS** 7.30pm £7 / dancecard

Take time out \P Forget about the stresses and strains of everyday living ¶ Soma will make you focus on the important things ¶ ... the perfect antidote to the impossible pace of modern life. ¶ Three talented choreographers have come together to explore the concepts of mind, body and soul and how they can be translated into movement. The result is surprisingly evocative, inspirational dance that is a departure from the company's signature 'street dance' styles. Soma will resonate with RJC's distinctive energy and dance form which draws its inspiration from reggae, jazz and contemporary dance techniques. ¶ Powerful & empowering — The Guardian ¶ Phenomenal dancers — Independent on Saturday

SOMA MINOBOD

FRI.07 - SAT.08.FEB LYCEUM THEATRE RICHARD ALSTON DANCE COMPANY £16.50 / dancecard 25% off / concs p22 7.4500

> Richard Alston makes dances which speak directly about movement and music and their combined power to move and elate. He is a choreographer for whom every dance is a love affair with his chosen music --- The Times. The twelve dancers are wonderful exponents of his fluent, lively style and continue to attract critical and public praise wherever they perform. ¶ The Sheffield performances feature Alston's latest creation for his full company Stampede, (hot, dark and dangerous dance — The Guardian) set to the exotic Moorishinfluenced sounds of Italian mediaeval music. A Sudden Exit, accompanied by Brahms's beautiful late piano music played live, is a truly moving work exploring the pain of abrupt departure - The Independent on Sunday hailed it as a small masterpiece. The evening climaxes with Touch and Go capturing the insistent pull of Argentinian tango. Astor Piazzolla's music provokes a mood of restless excitement and strange stirrings of repressed desire. ¶ an unexpected pleasure...sheer, joyful spontaneity - The Sunday Times.

11

SUDDEN EXIT CH AND GO

EDUCATION WORK ON OFFER SEE P16

BEACHBIRDS SERGEANT**EARLY'S**DREAM THECELEBRATEDSOUBRETTE

RAMBERT DANCE COMPANY

LYCEUM £8.50 - £18.50 [£5 standbys] / concs P23 7.45PM

BADFAITH**AND**SYMBIOSI "COLIN POOLE

ROTHERHAM ARTS CENTRE £6.50 / £4.50 concs 7.30PM TUE.30.JAN

Quite simply, the best — The Matl on Sunday ¶ Beach Birds inspired by images of seabirds, Merce Cunningham's hypnotic and sparsely beautiful Beach Birds epitomises his unique and expressive approach to dance. ¶ The dancers of Rambert are fantastic ----The Times ¶ Sergeant Early's Dream Inspired by Irish, British and American folk music and songs, this suite of dances is both comic and poignant. For this nostalgic ballet, the nine dancers are joined on stage by The Sergeant Early Band. ¶ The Celebrated Soubrette A dazzling, Las Vegas inspired new work from the flamboyant choreographer Javier de Frutos. A true audience pleaser Daily Telegraph. ¶ Free Pre-Performance Talk. Thu 18 Jan, 6.45pm in the auditorium.

Education Matinee — Swansong in Focus Thu 18 Jan at 2pm £6. ¶ Rambert Education in service training session Wed 17 Jan, 4 pm - 6 pm in Crucible Rehearsal Room. Open Workshop Sat 20 Jan, 10 am -12 noon. For teenagers and adults with some dance experience. Tickets £8 from Rambert Education. ¶ Please send a large sae and cheque made payable to Rambert Dance Company to: Rambert Education, 94 Chiswick High Road, London W4 ISH. Workshops for schools, in-service sessions for teachers and educational research please contact Rambert Education on 020 8994 2366 or rdc@rambert.org.uk

A star is born and his name is Colin Poole ---- Evening Standard 1 Two fabulous duets from the exceptional Colin Poole offer an evening of dance which will inspire and entertain. Bad Faith is provocative and comic, exploring seduction, sex and deceit. By contrast, Symbiosis has a powerful emotional quality and an eloquent movement language. ¶ Colin Poole has been a member of many of England's leading dance companies, notably Phoenix and Rambert Dance and is now recognised as one of the hottest new choreographers on the British dance scene. He was previously Associate Artist at The Place and is now Artist in Residence at Greenwich Dance Agency. ¶ Highly concentrated and competing --- Sunday Times ¶ In Bad Faith, he is joined onstage by Rachel Krische [Bedlam and Alleta Collins]. He performs Symbiosis with Heather Regio Duncan.

LIENT		
EPLAY 8	SONS	

C

DESIGN CHIARA GRANDESSO LIONELLO BOREAN

ART DIRECTION CHIARA GRANDESSO ILLUSTRATION CHIARA GRANDESSO LIONELLO BOREAN

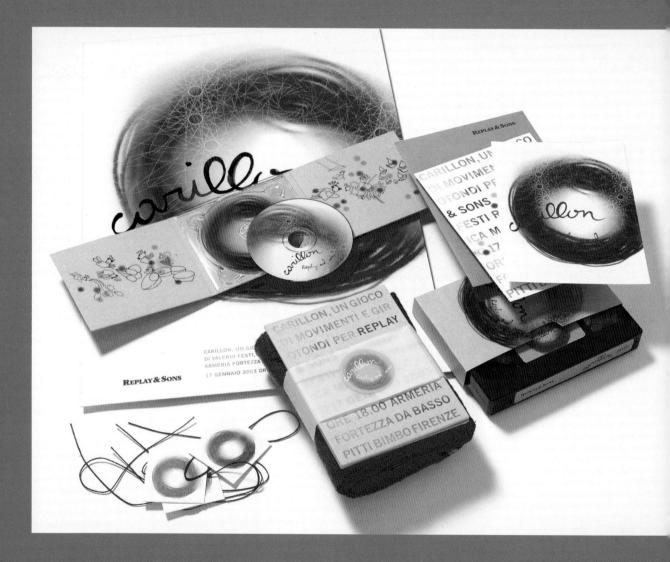

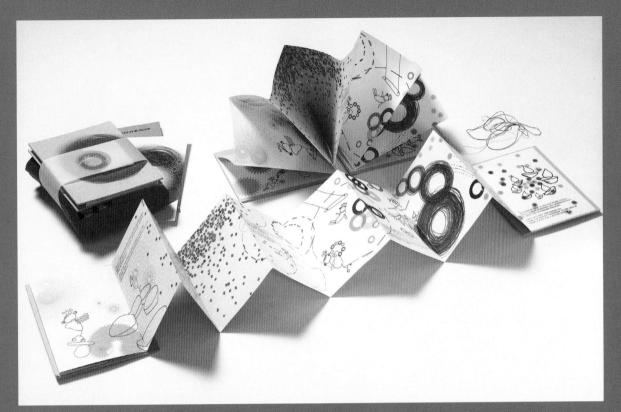

USINE DE BOUTONS CARILLON, IDENTITY PACKAGE Striking calligraphy play and

striking calligraphy play an important role within the

hierarchy of Carrillon, designed for Replay & Sons. However, it is the bold use of the large, bright orange, circular image that really captures the viewer's attention. This distinctive hue is replicated within other items in the identity-including textile products, postcards, and label ties-and acts as a focus that pulls viewers from orange to orange, and to the less impactive surrounding information.

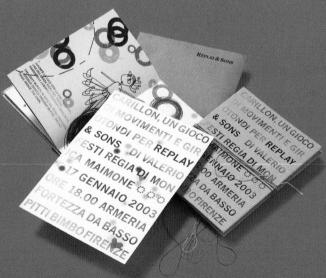

CLIENT MEM MOBRISON DESIGN DOM RABAN ART DIRECTION

EG.G SHOWROOM THEATER POSTER

This Showroom poster was an interesting challenge, particularly from a

hierarchical point of view: it has to work as a cohesive whole and as six individual flyers. The whole poster therefore includes the same information six times. This is skillfully varied in scale and interpretation so as not to appear repetitive or symmetrical. Each individual flyer has a strong focal emphasis and sufficient supporting visual material to give it credibility. The 18-column grid of the whole (breaking down into six three-column flyers) acts both as a unifying and dividing device. By combining type in bars with iconic images, the demarcation between type and image is blurred, allowing intensity of color and tone alone to draw in the eye of the viewer.

Éliminatoires **Où? Parc Miribel – Lyon** Quand? 1e Mai 2004 à 10:00 heures

we, sortie 4 Parc de Miribel-Jonaj a Rize / Parc de Miribel-Jonage.

ve will add a few w ome au 0.805.404.404

PUMA le site www.pumawomen.com

SoundSystem[®]. Be entertained by our own female 4some

DESIGN

BOB COKE

ve)

CLIENT MTV NORTHERN EUROPE

TYPOGRAPHY ROB COKE

ART DIRECTION COPYWRITING OTTO RIEWOLDT ROB COKE

ILL USTRATION BOB COKE

STUDIO OUTPUT

Although a great deal of type is included in all these posters, we have included

them in the image-driven section of this book for two reasons; firstly, the images are either of animated, cut-out figures or of powerful red, orange, and green rastafarian circles both of which immediately draw attention; secondly, the type, which includes a number of namestyles, uses the same color combinations as the images, reversed through allover black or blue backgrounds. Therefore, type merges into image so that each poster is perceived instantly on an image basis before it is "unpacked" for information. As far as the hierarchy of this data is concerned, it is likely that tonal values of each element take a reader from light to dark; familiar aspects draw more attention, and individuals' personal "need to know" requirements will influence their point of entrance.

344 DESIGN, LLC

101 N. Grand Avenue #7 Pasadena, California 91103, USA T: +1 626 796 5148

BLUE RIVER DESIGN LTD. Kings House, Fourth Banks, Newcastle, Tyne and Wear NE1 3PA, UK T: +44 (0)191 261 0000 F: +44 (0)191 261 0010

BRAHM DESIGN Brahm Building, Alma Road, Headingley, Leeds, West Yorkshire LS6 2AH, UK T: +44 (0)113 230 4000 F: +44 (0)113 230 2332

BRIGHT PINK COMMUNICATIONS DESIGN Lapley Studio, Lapley, Stafford ST19 9JS, UK T: +44 (0)1785 841601 F: +44 (0)1785 841401

BUREAU FOR VISUAL AFFAIRS 24 Southwark Street, London SE1 1TY, UK T: +44 (0)207 407 2582

CHENG DESIGN 505 14th Avenue E #301, Seattle, Washington 98112, USA T: +1 206 328 4047 F: +1 206 685 1657

DOYLE PARTNERS 1123 Broadway, New York, New York 10010, USA T: +1 212 463 8787 F: +1 212 633 2916

DWELL

99 Osgood Place, San Francisco, California 94133, USA T: +1 415 743 9990 F: i1 415 743 9978

EG.G

Swan Buildings, 20 Swan Street, Manchester M4 5DW, UK T: +44 (0)161 833 4747 F: +44 (0)161 833 4848

FISHTEN 2203 32nd Avenue, SW Calgary, Alberta T2T 1X2, Canada T: +1 403 228 7959

FORM FUENF BREMEN Graf Moltke Strasse 7, 28203, Bremen, Germany T: +49 421 703074 F: +49 421 703740

GEE + CHUNG DESIGN 38 Bryant Street, Suite 100, San Francisco, California 94105, USA T: +1 415 543 1192 F: +1 415 543 6088

GR/DD GRAPHIC RESEARCH DESIGN DEVELOPMENT 173 Clapham Road, Stockwell, London SW9 0QE, UK T: +44 (0)207 733 2287 F: +44 (0)207 733 2257

GRANT MEAK 15B Westbourne Street, Walsall, West Midlands WS4 2JB, UK T: +44 (0)1922 624643

HOLLER 151 Farringdon Road, London EC1R 3AF, UK T: +44 (0)207 689 1940

IDENTIKAL

9A Wood Lofts, 30–40 Underwood Street, London N1 7JQ, UK T: +44 (0)207 253 6771 F: +44 (0)795 749 7569

IE DESIGN + COMMUNICATIONS 422 Pacific Coast Highway, Hermosa Beach, California 90254, USA T: +1 310 376 9600 F: +1 310 376 9604

JOHNSON BANKS Crescent Works, Crescent Lane, Clapham, London SW4 9RW, UK T: +44 (0)207 587 6400 F: +44 (0)207 587 6411

KINETIC, SINGAPORE 2 Leng Kee Road, Thye Hong Ctr #004–03 159086 Singapore T: +65 637 95320 F: +65 647 25440

MATEEN KHAN 4 Kirby Road, Leicester LE3 6BA, UK T: +44 (0)116 299758

MIRKO ILIC CORP. East 32nd Street, New York, New York 10016, USA T: +1 212 481 9737 F: +1 212 481 7088

MUGGIE RAMADANI

Rosenvængets Allé 17B, 3rd Floor, Copenhagen – Østerbro DK2100, Denmark T: +45 40748930

NB: STUDIO

24 Store Street, London WC1E 7BA, UK T: +44 (0)207 580 9195 F: +44 (0)207 580 9196

NON-FORMAT

2nd Floor East 88–94 Wentworth Street, London E1 7SA, UK T: +44 (0)207 422 5035

ODED EZER DESIGN STUDIO

9 Bloch Street, Givatayim 53229, Israel T: +972 3 672 5489 F: +972 3 672 5489

PHILIP FASS

University of Northern Iowa, 104 Kamerick Art Building, Cedar Falls, Iowa 50614, USA T: +1 319 277 6120 F: +1 319 273 7333

PISCATELLO DESIGN CENTRE 355 Seventh Avenue, New York, New York 10001, USA T: +1 212 502 4734 F: +1 212 502 4735

POULIN + MORRIS INC. 286 Spring Street, 6th Floor, New York, New York 10013, USA T: +1 212 675 1332 F: +1 212 675 3027

RADFORD WALLIS 3rd Floor, 27 Charlotte Road, London EC2A 3PB, UK T: +44 (0)207 033 9595 F: +44 (0)207 033 9585

REBECCA FOSTER DESIGN

54 Cassiobury Road, London E17 7JF, UK T: +44 (0)208 521 8535 F: +44 (0)208 521 5784

RECHORD

Innovation Labs, Harrow Campus, Watford Road, Harrow HA1 3TP, UK T: +44 (0)20 8357 7322 F: +44 (0)20 8357 7326

SAGMEISTER INC.

222 West 14 Street, New York, New York 10011, USA T: +1 212 6471789 F: +1 212 6471788

SAS

6 Salem Road, London W2 4BU, UK T: +44 (0)207 243 3232 F: +44 (0)207 243 3216

SCANDINAVIAN DESIGN GROUP P.O. Box 4340 Nydalen, Oslo, N-0402 Norway T: +47 2254 9500

SPARKS PARTNERSHIP

85A Goldsmiths Row, Bethnal Green, London E2 8QR, UK T: +44 (0)20 7240 7181

SPIN

12 Canterbury Court, Kennington Park, London SW9 6DE, UK T: +44 (0)207 793 9555 F: +44 (0)207 793 9666

STUDIO OUTPUT LTD. 2 The Broadway, Lace Market, Nottingham NG1 1PS, UK T: +44 (0)115 950 7116 F: +44 (0)115 950 7924

STUDIO VERTEX 108 S. Washington Street #310, Seattle, Washington 98104, USA T; +1 206 838 2450

SURFACE MAGAZINE 1663 Mission Street, Suite 700, San Francisco California 94103, USA T: +1 415 575 3100 F: +1 415 575 3105

TAXI STUDIO LTD. 93 Princess Victoria Street, Clifton, Bristol BS8 4DD, UK T: +44 (0)117 973 5151 F: +44 (0)117 973 5181

TEIKNA GRAPHIC DESIGN INC. 401 Logan Avenue #208, Toronto, Ontario M4M 2P2, Canada T: +1 416 504 8668 F: +1 416 465 9998

USINE DE BOUTONS Via G. Franco 99B, Cadoneghe, Padua 35010, Italy

T: +39 (0)49 8870953 F; +39 (0)49 8879520

WAITROSE LTD. Don Castle Road, Bracknell, Berkshire RG12 8YA, UK

WILSON HARVEY

Crown Reach, 147a Grosvenor Road, London SW1V 3JY, UK T: +44 (0)207 420 7700

Z3 DESIGN STUDIO INC.

Loft 2 Broughton Works, 27 George Street, Birmingham B3 1QG, UK T: +44 (0)121 233 2545 F: +44 (0)121 233 2544

INDEX

Abbink, Jeanette Hodge 121, 137 Abbott, Isabel 103 adverts 13, 63 annual reports 55, 90, 111, 136 attention-grabbing devices 4, 83, 126, 151

Bache, Mikkel 45, 139 Bane, Alex 26 Bastian, Daniel 83 bias 83 Blaszczuk, Magdalena 44 Blue River Design 20, 23 body language 82 books 18, 56-7, 76, 78, 80, 84, 117 Borean, Lionello 154 Bowden, James 101, 141 Bradley, Lee 55, 57, 62, 69, 73, 84-5, 95 Brahm Design 55-7, 62, 69, 72-3, 84, 95 Bright Pink 70, 75, 91 broadsheets 82 brochures 4, 9, 72-3, 75, 83, 88-9, 112-13, 152-3 Brook, Tony 13, 54, 63 Bucher, Stefan G. 34, 41, 52, 60, 66, 80, 147 Buck, Spencer 26, 116 Bureau for Visual Affairs 110, 122, 142 Burgess, Paul 112, 148 Burrin, Joe 13, 54, 63 Byrne, Nina 20

calendars 23, 67 Carson, Marcie 22, 42-3, 94 Cartwright, Jo 152 catalogs 14, 20, 47, 61, 81, 123, 145 CD packaging 8, 60, 66, 74, 97, 143, 147 **Cheng Design 10** Cheng, Karen 10, 15 coasters 104 Coke, Rob 24, 157 Collinson, Rachel 35, 74, 96 color 4, 7, 36, 50-1, 82, 151 composition 6, 82, 99, 126, 150 continuance 36-7 Cordova, Ted 42 Crabtree, Tom 13, 63 cropping 82, 98-9, 150

cultural imagery 83 cut-and-paste visualizing 16–17

Davidsen, Catherine Raben 5 Debens, Andrew 132–3 Depredurand, Julien 101, 141 344 Design 34, 41, 52–3, 60, 66, 80, 147 design alternatives 150 Douglas, Simon 23 Doyle Partners 25 Doyle, Stephen 25 Dwell Design Dept. 121, 137 Dye, Alan 87, 102, 120, 129, 136

Eg.G 9, 40, 100, 109, 114, 134, 152–3, 156 Ekhorn, Kjell 8, 12, 44, 86, 118 Elsner, Paul 110, 122, 142 Ernstberger, Matthias 90 exercises cropping and change of scale 98–9 cut-and-paste visualizing 16–17 image hierarchy and manipulation 126–7 layout diversity 150–1 proximity, continuance, and similarity 36–7 sequencing text 64–5 type and color 50–1 Exquisite Corporation 83, 92, 105–7, 128 eyes 82 Ezer, Oded 135

facial expressions 82 Fass, Philip 21, 28, 131 Finney, Nick 87, 102, 120, 129, 136 Fishten 14, 47, 61, 81 folders 94–5 Form Fuenf Bremen 83 Forss, Jon 8, 12, 44, 86, 118 Foster, Rebecca 38–9

Gee + Chung Design 30, 104 Gee, Earl 30, 104 Gifford, Lisa 93 Glaser, Jessica 75, 91 GR/DD Graphic Research Design Development 101, 108, 141 Graham, James 129 Grandesso, Chiara 154 graphic sandwich 4, 44, 55 grayscale 7, 150–1 Gudnason, Torkil 106

hand gestures 82 handbooks 129 Hartman, Kelly 14, 47, 61, 81 Hayes, Adam 48–9 Hayes, Nick 48–9 Hazen, Shawn 137 Helvetica family 150 Hemmingfield, Paul 109, 152 Hinegardner, Heath 59 Holler 71, 77 Howe, Mark 84 Hunt, Richard 125, 143

Identikal 48–9 identikal 48–9 identities 45, 54, 122, 132–3, 138–9, 155 IE Design + Communications 22, 42–3, 94 Ilic, Mirko 59, 78, 115 images categories 4 hierarchies 82–157 layout diversity 150–1 manipulation 126–7 induction kits 116 information levels 4 invitations 28, 131

Jarman, Derek 144 johnson banks 19, 68, 93 Johnson, Michael 19, 68, 93 juxtaposition 82

Khan, Mateen 46, 58, 79 Kinetic 97 Knight, Carolyn 70, 75, 91 Kwon, Amy 117

layout diversity 150–1 Lee, Penny 57 Leng Soh 97 letterforms 6 Lindsay, Michael 15 McAlinden, Gavin 35 McFarlane, lan 13, 63 MacIlwaine, Gary 74 Madsen, Per 5, 123, 145 magazines 12, 31, 44, 62, 86, 92, 103, 105, 118-19, 121, 128, 137 mailers 11 manipulation of images 126-7 Mateen Khan Design 46, 58, 79 memoranda 30 metaphor 83 metonymy 83 Miller, Hugh 13, 63 Mirko Ilic Corp. 59, 78, 115 mood 4 Moore, Dan 24 Morris, Douglas 67 Morritt. Jo 134 mouths 82 moving cards 59 Muggie Ramadani Design Lab 45 multimedia 79 Munthe plus Simonsen 5, 145

NB: Studio 87, 102, 120, 129, 136, 144 Neri, Claudia 130 newsletters 22 newspapers 82 Non-Format 8, 12, 86, 118–19

Pann Lim 97 Piehl, Simon 122, 142 Pierce, Ian 87 **Piscatello Design 29 Piscatello, Kimberly 29** Piscatello, Rocco 29 Poh, Roy 97 positioning 99 postcards 15 posters 4 image-driven 93, 102, 109, 114, 120, 134-5, 144, 156-7 type-driven 10, 15, 19, 21, 24, 29, 41, 58, 68, 78 Poulin + Morris 67, 76, 117 Poulin, L. Richard 67, 76, 117 Poyner, Dan 13, 63

press kits 115 prizes 87 programs 32–3 prospectuses 40, 124–5 proximity 36–7 publications 100 Pyne, Will 77

Raban, Dom 9, 40, 100, 114, 134, 152, 156 Radford, Stuart 11 Radford Wallis 11, 33 Ramadani, Muggie 5, 45, 89, 123, 139, 145 Raybould, Scott 125 Rebecca Foster Design 38–9 rechord 35, 96 reviews 91, 148–9 Rossetti, Christina 75

Sagmeister, Stefan 90 SAS 18, 111 scale 7, 36, 82, 98-9, 126, 150-1 Scandinavian Design Group 5, 88-9, 123, 138-9, 145 scene-setting 83 Schulz, Lauren 83, 106 sentimentality 82 similarity 36-7 Smith, Richard 92, 105, 128 space 5 **Sparks Partnership 74** Spearin, Gary 47 Spencer, Andy 111 Spin 13, 54, 63 Starbuck, Mark 73, 84 stationery 26-7, 70 Stott, Ben 87, 102, 120, 129, 136 Studio Output 24, 157 **Studio Vertex 15** subconscious 5 subject matter 82 substitution 83

tabloids 82 Tartakover, David 135 Taxi Studio 26–7, 116 Teikna Graphic Design 130 text

categories 4 large quantities 64–5 layout diversity 150–1 sequencing 64–5 texture 6–7, 82 theater campaigns 38–9 Thundercliffe, Lisa 20, 23 tints 83 tone 6–7, 82, 151 Tyler, Zoe 95 type-driven hierarchies 6–81 typefaces 7, 150

updates 82 Usine de Boutons 155

viewbooks 42–3 Vincent, Nick 120, 136 violence 82 visual hierarchy types 4–5, 82–3

Wai Lau 148
Walker, Pat 9
Wallis, Andrew 11
Waters, Dave 55, 62
Web pages 4, 34–5, 48–9, 71, 77, 96, 101, 110, 122, 142
wedding stationery 70
Wendt, Gilmar 18
Western reading conventions 6
White, Henry 38
Wills, Ryan 26, 116
Wilson Harvey 112–13, 148–9
Woodward, Giles 14, 47, 61, 81
words 6–7

Year of The Artist 9 Yuen, Simon 101, 141

Z3 Design Studio 124-5, 132-3, 140, 143